LOST RAILWA
OF HEREFORDSHIRE
AND WORCESTERSHIRE

*Other Railways titles available from
Countryside Books include:*

Cheshire Railways Remembered

Lost Railways of the Chilterns

Lost Railways of Dorset

Lost Railways of East Anglia

Lost Railways of Hampshire

Lost Railways of Surrey

Lost Railways of Sussex

LOST RAILWAYS
OF HEREFORDSHIRE
AND WORCESTERSHIRE

Leslie Oppitz

COUNTRYSIDE BOOKS
NEWBURY, BERKSHIRE

The cover painting by Colin Doggett shows GWR locomotive 4-6-0
Raveningham Hall no 6960 hauling an express train through Pontrilas
station in the mid 1940s. The locomotive is currently to be found at
the Gloucestershire Warwickshire Railway.
Maps by Jennie Collins

Produced through MRM Associates Ltd., Reading
Printed by Woolnough Bookbinding Ltd., Irthlingborough

CONTENTS

Introduction

The attractive railway station of Fencote can be found in a hollow not far from the village of Hatfield nearly 7 miles east of Leominster. There are two platforms complete with booking office, waiting rooms and a parcels office and on a wall hang the customary GWR fire buckets. Milk churns stand on a trolley awaiting collection. Nearby a poster reads 'Barmouth for mountains, sea and sand' while a GWR timetable announces 'Services from October 1944 until further notice...'

There, unhappily, the illusion ends for today trains no longer call at Fencote and the line has long since been closed. When visited in June 2001, Fencote station was a strictly private residence cherished by its present owner. Every effort has been made to restore the original from the derelict station that was taken over after its closure in September 1952 – some 50 years ago.

Unhappily many of the stations which have closed throughout Hereford and Worcester have not been so enthusiastically restored. Old station buildings, engine sheds, road bridges or overgrown trackbeds all go to make up what was once a busy network of railways, when steam trains made their way across open stretches of countryside linking remote villages and towns.

Early ideas for railways in Hereford and Worcester included horse-drawn tramways. Canal traffic was taking too long and road conditions were proving equally unsatisfactory. Early in the 19th century three tramways, calling themselves 'railway companies', opened to provide transport between the coalfields around the river Usk and Hereford with its agriculture, cattle and sheep. By the late 1820s such 'railways' also included the Kington Tramway connecting limestone quarries with the 'Hay Railway' of 1818 at Eardisley.

The 1820s also proved important years for the introduction of the conventional railway known today. To the north there were activities following George Stephenson's enthusiasm over loco-

11

motive engines. With the opening of the Stockton to Darlington Railway in 1825, the first steam train had arrived. There were stirrings too between Bristol and Birmingham. A company known as the Bristol, Northern & Western Railway aimed to open up freight traffic between Birmingham and the sea but, largely due to lack of funds, this and a number of ideas that were to follow were not taken up.

Eventually it fell to the Birmingham & Gloucester Railway (B&GR) to provide a link between the two towns. From the start the company had financial problems and it was decided that Tewkesbury, Worcester and Droitwich would be avoided due to the extra mileage involved and also partly because of the high cost of land near the towns. Another problem had been the prospect of the Lickey Incline (as it became known) between Bromsgrove and Barnt Green with an anticipated gradient of 1 in 37½. Numerous ideas were put forward to take an alternative route but these were rejected since it meant further towns along the route would have been omitted. The company obtained Parliamentary approval in April 1836 but it was not until 17th August 1841 that the B&GR linked Gloucester with the main London and Birmingham Railway.

When a line opened between Bristol and Gloucester, there was a gauge problem. The line from Bristol had been built to Brunel's Great Western Railway (GWR) broad gauge system of 7 ft 0¼ ins whereas the B&GR (later absorbed by the Midland Railway) was operating a narrow gauge system of 4 ft 8½ ins (later accepted as standard gauge). Platforms at Gloucester had to be built alongside each other so that goods could be transferred! The break of gauge remained a problem for many years and it became of national interest. The area was soon to become a battleground between the GWR broad gauge pushing northwards and the Midland Railway's standard gauge equally anxious to press across the region. It was to be some considerable time before the matter was resolved. In 1846 a Gauge Commissioners' Report opposed any extension of the broad gauge.

The first train to reach a temporary station at Worcester came

on 5th October 1850. This became possible when a spur opened between Abbotswood junction (north of Wadborough) and Worcester. Further lines across the region were quick to follow. Hereford was reached on 6th December 1853 when a standard gauge line was completed from Shrewsbury. The line opened up possibilities to link the industrial north with the rich coalfields in South Wales particularly when a line opened between Hereford, Abergavenny and Newport the following year. Battles were soon to follow between the GWR and the London & North Western Railway (LNWR) over access to the route.

The ensuing chapters cover the many lines that came into being, the majority of which later suffered under the Beeching axe. Also included are the preserved railways – the Severn Valley Railway and the Gloucestershire Warwickshire Railway – which play an important part in the region. In addition, the opportunity is taken to look at those 'lost lines' which crossed the counties' borders since these also had a role to play.

This book sets out to examine the formation and lives of Hereford and Worcester's railways as well as, where relevant, their decline and closure. It also provides the reader with a means to explore the many lost stations that can still be found and trackbeds that have survived, some now converted to roads but others turned into footpaths.

1
Across The Vale Of Evesham

Great Malvern/Tewkesbury/Ashchurch/
Evesham/Redditch

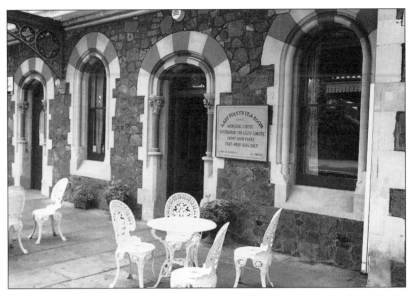

A prominent feature at Great Malvern station for many years has been 'Lady Foley's Tea Room'. Lady Foley was at one time the town's formidable lady of the manor. She frequently used the station and the waiting room was furnished especially for her. (Author)

Although Great Malvern station has lost its original front canopy and clock tower, it has retained its attractive 1861 Gothic style with its fine buildings and station house still in use. On the platform the canopies are supported by elaborately decorated columns and the former first class waiting room used by Lady Foley is still in existence. Lady Emily Foley, the town's formidable

15

lady of the manor, often drove from her seat at Stoke Edith to Great Malvern where she would continue her journey by train. This frequently necessitated a wait at the station so the waiting room was furnished especially for her. She was described as a woman who 'rightly disliked travelling by train through the dirty tunnels'. By travelling by road to Great Malvern she had of course avoided Ledbury and Colwall tunnels. As a reminder of the past, it is possible today to enjoy morning coffee or after-noon tea at 'Lady Foley's Tea Room' which can be found on the up platform.

Rail travel to the town was popular and hotels were built to cater for the visitors. Both Great Malvern station and the nearby Imperial Hotel were designed by E. W. Elmslie. The Imperial claimed when first built that it was the only hotel in England to be lit by incandescent gas. It also claimed that its baths provided a 'water cure' and its dining room could seat one hundred guests. Recognising the need for rail travel, a private passage-way (now disused) was built linking the hotel with the station for both passengers and goods. Today the hotel is a girls school.

The Midland Railway line from Great Malvern through Tewkesbury and across the Vale of Evesham was initially pro-moted by separate and independent companies. These included the Birmingham & Gloucester Railway, the Tewkesbury & Malvern Railway, the Midland Railway, the Evesham & Redditch Railway and the Redditch Railway. A short section of the route opened as early as July 1840 when the Birmingham & Gloucester Railway opened a 1¾ mile branch between Ashchurch and Tewkesbury. The branch was extended to Great Malvern by the Tewkesbury & Malvern Railway in May 1864 when a new station was opened at Tewkesbury.

Great Malvern/Tewkesbury/Ashchurch

First indications of a line linking Malvern and Ashchurch came at the end of 1859 when the *Berrow's Worcester Journal* reported that plans were already in hand. The newspaper doubted that

such a line was needed particularly since the first section of a line from Worcester to Hereford had only just been opened, reaching Malvern Link from Hereford in 1859. Travel to Ashchurch via Worcester was therefore already possible, although on a longer and roundabout route. Despite this, meetings went ahead and there were plans to call the new company the 'Tewkesbury, Upton-on-Severn & Malvern Junction Railway'.

It was initially proposed that the line should leave the Midland Railway at the north end of Ashchurch station through a separate station at Tewkesbury, the latter to be built independent of the earlier 1840 terminus. Beyond Upton a junction with the Worcester & Hereford Railway was planned near Great Malvern station, beyond which a branch of less than one mile was to be built up the hillside to a separate terminus. To carry out the latter idea, it would be necessary to construct a 47-arch viaduct rising at 1 in 80 for 650 yards plus four further arches to cross the Worcester & Hereford line.

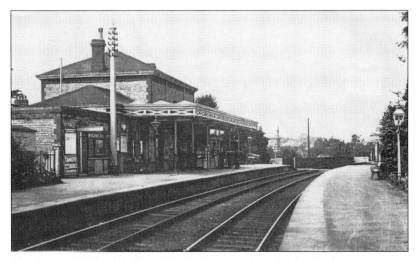

The former Midland Railway Tewkesbury station which closed to passengers in 1961. This was the town's second station, built when a branch to Malvern was opened in 1864. The town's original station was a terminus opened in 1840 adjoining the High Street. (Lens of Sutton)

17

Opposition came from the Midland Railway and also the West Midland Railway (about to absorb the Worcester & Hereford Railway) and the idea of a separate terminus at Malvern was dropped. At Tewkesbury it was agreed that trains would use the existing terminus adjoining the High Street. A Bill was prepared which passed through Parliament without difficulty. During the process the name of the company was shortened to the 'Tewkesbury & Malvern Railway' (T&MR). Also agreement was reached that at Tewkesbury a new station should be opened on the Malvern line and the old terminus should be closed. Share capital for the new line was set at £145,000 with borrowing powers for an additional £48,000.

The building of an 'opening bridge' across the Severn proved a costly venture. Six iron spans were involved with two brick arches on the west bank and one on the east. It was described as a 'telescopic bridge' where the second iron span could be rolled

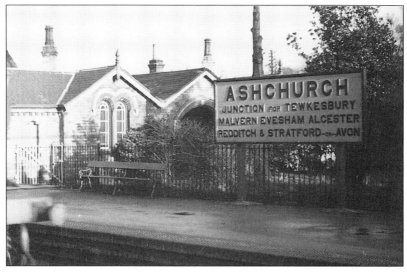

There was a time when Ashchurch was an important junction on the main Worcester to Gloucester line which also served Tewkesbury, Malvern and Evesham. The local train between Ashchurch and Malvern was known as the 'Tewkesbury Bullet.' (D.K. Jones Collection)

18

back, the rails on the first span being on hinged girders which could be folded over to provide clearance. The opening section had a span of 45 ft but when the inspecting officer visited the site in August 1863 the apparatus to draw back the rolling girders would not operate. No recommendation for change was made and the opening section was never used. In any event there appeared no need for such a bridge since vessels along the river could clear bridges with less clearance merely by lowering their masts.

Services between Great Malvern and Ashchurch commenced on 16th May 1864. There was no opening ceremony but early the following month the directors and their friends celebrated with a banquet and ball at the Star and Garter Hotel at Richmond in Surrey. There were initially four trains each way on weekdays and two on Sundays, all worked by the Midland Railway. The line had been built with double track although the reasoning

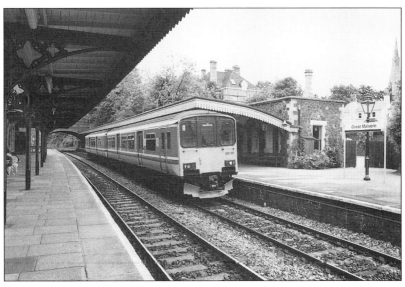

A Hereford bound diesel set awaits departure from Great Malvern station June 2001. Prior to December 1952 trains left Great Malvern for Tewkesbury and Ashchurch four times each way daily on weekdays only. (Author)

19

The former Ripple station photographed from the air in 2001. In its time this Midland Railway station served a small village in a very isolated rural area. (Photograph courtesy of Barry Young)

had been hard to understand. It is thought that the directors might perhaps have envisaged through trains between Gloucester and Birmingham via Malvern.

Prospects for passenger traffic were poor. A coach service between Malvern and Cheltenham had failed even before the railway had commenced! At first the Midland persevered with the initial pattern of services but at the end of October 1867 it was decided that Sunday services should be withdrawn. A freight service was encouraged and during the next few years goods and coal sidings were opened near the junction at Great Malvern. After deduction of working expenses for the Midland Railway, the T&MR had insufficient cash remaining to meet the

20

interest due on the debentures and bonds. It was hardly sur-
prising when in 1876 the Midland successfully applied to
Parliament to take over the smaller company from 1st January
1877.

Intermediary stations included Malvern Wells (Hanley Road),
Upton-on-Severn and Ripple. These were in addition to the new
Tewkesbury station built to replace the earlier Midland termi-
nus. As travel increased in popularity in the late Victorian
period so services increased. In 1890 a through service of one
train a day commenced between Malvern and Cheltenham and
in 1902 through carriages reached Bristol. The through train
from Cheltenham to Malvern became a regular feature and it
was still operating in 1946 although rather unusually there was
no corresponding through train in the opposite direction. The
train normally comprised one non-corridor coach and it was
hauled by a 4-4-0 class 2 locomotive in contrast to the 0-4-4T
locomotives usually seen on the line. Other through trains,
generally on a Sunday, came from the Birmingham area via
Bromsgrove reversing at Ashchurch.

In 1913 the up line between Tewkesbury and Upton was given
up to wagon storage which meant that the down line, now effec-
tively single-track, had to be worked by pilot-men. In 1929 the
line saw additional traffic when it was used as a diversionary
route after a bad accident at Ashchurch. In the early morning of
January 8th the driver of an up express from Bristol to Leeds
overran signals in fog when approaching Ashchurch and
crashed at 50 mph into a goods train crossing from the up to the
down line. Damage to the coaches and wagons was described as
'catastrophic' but fortunately there were few passengers on the
train and only four died.

The line continued to survive for a number of years after the
Second World War. In 1951 British Rail formally identified the
line's Malvern Wells station as 'Hanley Road' although
Bradshaw's had already being doing this for many years. During
its last years the station lapsed into a sorry and dilapidated con-
dition, a poor state of affairs since in earlier times it had won
numerous awards for its gardens.

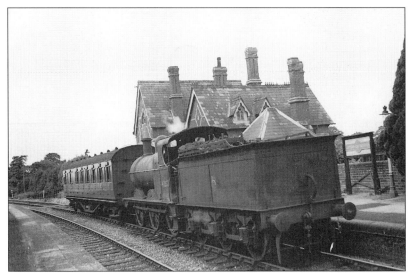

Ex-Midland Railway locomotive no 43337 0-6-0 class 3F (also LMS class 3F) and coach await departure in the early 1950s from Upton-on-Severn station on the line between Malvern and Tewkesbury. The station finally closed to passengers on 14th August 1961. (D.K. Jones Collection)

On 1st December 1952 all services were withdrawn between Upton and Malvern leaving the goods sidings near Great Malvern to be served by trains from Worcester until the end of April 1968. The remainder of the line from Upton to Tewkesbury ceased on 14th August 1961 for passengers with goods being withdrawn on 1st July 1963. The Tewkesbury & Malvern venture had been a costly one throughout its life and none the less so when a short diversion was constructed between 1958-1960 to carry the line over the new M50 motorway by a bridge shared with a minor road. This was completed just one year before the passenger service was withdrawn.

Malvern Wells-Hanley Road station has gone today, similarly Upton-on-Severn where the site has become Upton Industrial Estate. When I visited the area in July 2001 no trace of the station could be found and many at the site were not even aware that it

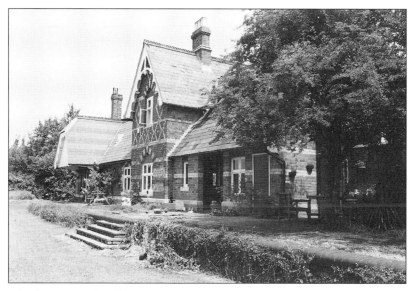

Ripple station closed to passengers in August 1961 and to goods in July 1963. Today the station building serves as an attractive private residence. (Author)

was once a railway station. Yet Ripple station building has survived as an attractive private residence with the platform very much in evidence. What seemed surprising was that such a grand building had been established in what was a very isolated area.

Ashchurch/Evesham/Redditch

One of the disadvantages of the Midland Railway main line from Gloucester to Birmingham, opened in December 1840, was that it bypassed many of the important fruit and vegetable growing towns in the Vale of Evesham. Another inconvenience was the Lickey Incline between Bromsgrove and Barnt Green. It soon became apparent that rail communication was needed in the Vale and in this way the Midland's loop line was created. Yet

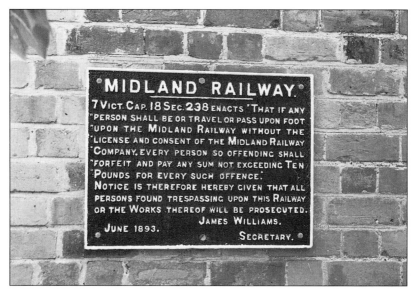

This Midland Railway notice has been preserved on the wall of the former Ripple station building warning that trespassers may be fined up to £10. (Author)

it took three separate companies to see it through.

On 23rd July 1858 Parliament agreed plans submitted by the Redditch Railway for a single-line branch from Barnt Green on the Birmingham & Gloucester to Redditch. Established as a New Town in 1964, Redditch was once a skilled metal industrial area, producing such items as motor cycles, fishing tackle and batteries. Trains first reached the town on 19th September 1859 with a terminus built to the north of the town.

Work to construct a rail link between Ashchurch and Redditch began at the southern end. The Oxford, Worcester & Wolverhampton Railway (OW&WR) had already opened a station at Evesham in 1852 and the Midland Railway was anxious to gain a share of the local traffic. Accordingly a branch between Ashchurch and Evesham was authorised in June 1861. It was completed on 1st October 1864 with its Evesham station built

24

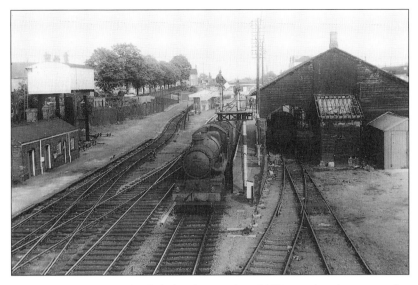

The 3.15 pm train hauled by locomotive 7025 awaits departure for Paddington from Evesham's GWR station on 4th June 1963. The semaphore signals and the water tank have long since gone. (R.K.Blencowe)

adjacent to the OW&WR station. Plans were already in hand to complete the remainder of the loop with the Evesham & Redditch Railway authorised on 13th July 1863. The stretch from Evesham to Alcester was opened to passengers on 17th September 1866 but the final link between Alcester and Redditch proved difficult. A tunnel was needed south of Redditch with deep cuttings at each end and much of the line was subjected to a long climb at a gradient around 1 in 120. In the years to come the climb often caused problems with engines running short of steam.

When the final section of the loop opened on 4th May 1868 the original terminus at Redditch closed and a new station was built at a site more convenient to the town centre. Between Redditch and Evesham the line comprised single track with passing loops whereas from Evesham to Ashchurch the track was double throughout. Meantime the independent companies had become

part of the Midland Railway which had worked the line from the outset. Just the Evesham & Redditch Railway remained nominally independent but this situation lasted only until July 1882. With the Midland Loop (as it was now called) open the Midland Railway had acquired a highly competitive access to Birmingham and to all parts of the country for the Vale's fruit and vegetable products. The OW&WR east-to-west route (now GWR) had become less strategically important.

At Ashchurch on the Gloucester-Birmingham main line, platforms serving Tewkesbury and Evesham curved outwards from the main station and to the north a line linked the two branches crossing the main line. Although this allowed through running from Evesham to Tewkesbury it was rarely used. Numerous substantially-built intermediary stations were constructed along the line. Between Ashchurch and Evesham they were stone-built whereas others to the north were made of brick.

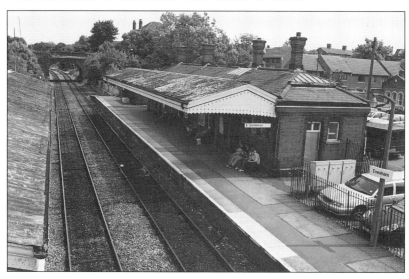

Evesham station, June 2001. Evesham once boasted two stations with the GWR and the Midland station sharing opposite sides of a forecourt. The GWR station seen here was part of the original Oxford, Worcester & Wolverhampton Railway. (Author)

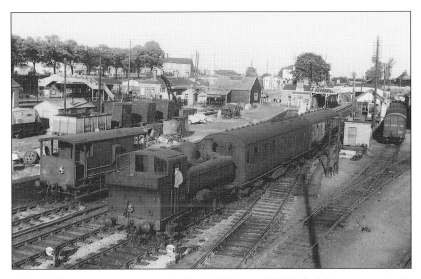

The 6.47 pm passenger train hauled by ex-GWR 0-6-0 pannier tank locomotive no 3745 leaves Evesham's Midland Railway station, 11th June 1963. On the far left is the GWR station with the goods yard occupying the centre ground (now a car park). (R.K. Blencowe)

During its life the loop remained busy particularly with seasonal fruit traffic, and sometimes special trains comprised up to 60 wagons. The goods yard at Evesham was continually busy, also including traffic transferred to and from the GWR. For many years the only connection between the two routes was through the sidings although this was rectified many years later to provide for Honeybourne-Cheltenham route diversions. Although on the GWR route, Littleton & Badsey (between Evesham and Honeybourne) is worth a mention. Before its closure in 1966 the station with its sidings had been an important loading area for fruit and vegetables, particularly asparagus.

Despite the importance of the loop, British Rail shocked the local population when it announced that, as from October 1962, services between Redditch and Evesham would cease because

of 'the unsafe condition of the line'. The section between Evesham and Ashchurch soon followed, closing for passengers on 17th June 1963. The Barnt Green to Redditch branch has survived to this day although the large area of sidings at Barnt Green also suffered under the Beeching axe. There must be many in that area who recall the times when the Royal Train stayed overnight in the sidings or even perhaps the high railway embankment which was a favourite spot for the release of racing pigeons sent by train.

Yet Redditch nearly lost its trains. During the Beeching era, BR announced that the branch would close but it was saved by four MPs tabling a Commons motion protesting that Redditch was about to become enlarged as a Birmingham dormitory

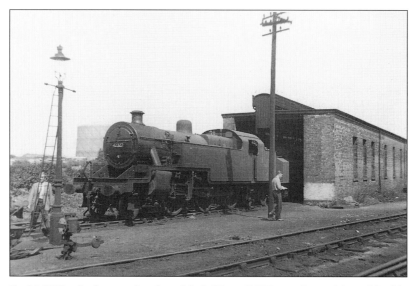

Ex-LMS Fowler locomotive class 4 2-6-4T no 42327 stands outside Redditch's sub-shed, July 1959. The locomotive was built at Derby in 1929 and survived until 1966. Until the 1960s, Redditch served trains on the Birmingham-Gloucester loop line from Barnt Green to Ashchurch via Evesham. Redditch is today a terminus at the southern end of Birmingham's Cross-City line. (R.K. Blencowe)

28

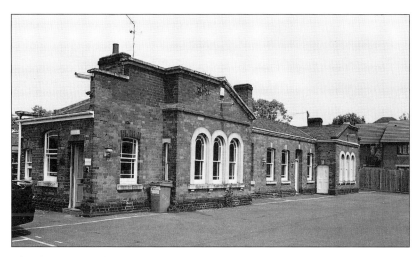

The former Evesham Midland Railway station building serves today as an office block. The station closed on 17th June 1963 with much of the site developed for the construction of houses and flats. (Author)

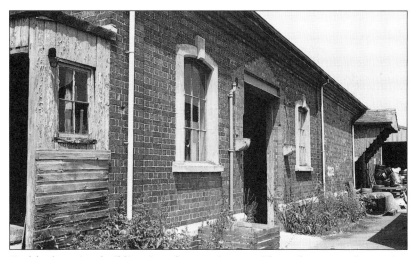

Beckford station building is today a private residence but a nearby engine shed survives as a store to a wholesale garden supplies company. Opposite a small building once housed horses used in earlier shunting days. (Author)

29

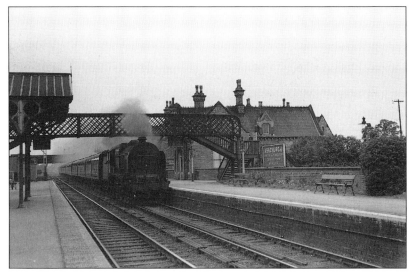

An express passenger train hauled by 4-6-0 locomotive no 45504 'Royal Signals' passes Ashchurch station on 8th August 1953. Ashchurch closed to regular goods traffic in June 1964 and to passengers in November 1971. (D.K. Jones Collection)

town. A reprieve was announced and today the town is served by a frequent Birmingham 'Cross-City' service from a new (third) station which was built to the north of the earlier 1868 site.

Other stations along the loop have survived – many as private dwellings. At Evesham part of the original red-brick Midland station buildings can be found opposite the present BR station and serving today as offices. Further south, Hinton station building is in industrial use, the area at Ashton-under-Hill has become 'Railend Nursery' and Beckford station building has become a private residence. The goods yard at Beckford is used by a wholesale garden supplier with the former goods shed used as a store. Opposite the store is a hut which once accommodated horses used to assist shunting.

Ashchurch on the main Cheltenham-Worcester line closed in

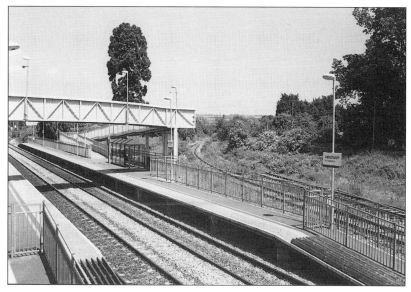

Ashchurch station (photographed June 2001) which reopened after public pressure in June 1997. The track curving to the right leads to the Ashchurch Central Vehicle Depot. (Author)

1971 but after public pressure it reopened as a new halt in 1997. Free parking was provided and a bus service linked passengers to Tewkesbury every half hour. Its reopening was largely financed by the County Council as part of its policy to discourage car congestion and pollution. A track curving to the east from the station leads to the Ashchurch Central Vehicle Depot. Tewkesbury station did not fare so well and, with the line closed, nothing remains of the station building. It is said locally that 'Friends of the Earth' would like to preserve the site as it is the habitat of a colony of glow-worms!

2
The Honeybourne Line

Cheltenham/Broadway/Honeybourne/
Stratford-upon-Avon
Steam returns to Toddington

Broadway's goods shed is today the headquarters of a Caravan Club site. The building was erected on a 'built-up' embankment so it had to be constructed on concrete pillars and iron girders reaching down to ground level. (Author)

Cheltenham/Broadway/Honeybourne/ Stratford-upon-Avon

There was a time when Broadway boasted a railway station through which expresses from Wolverhampton and Birmingham raced on their way to Wales or Weston-super-Mare and the West. Today the station is no more although the goods shed on the south-west side of the A44 (the depot closed in June 1964)

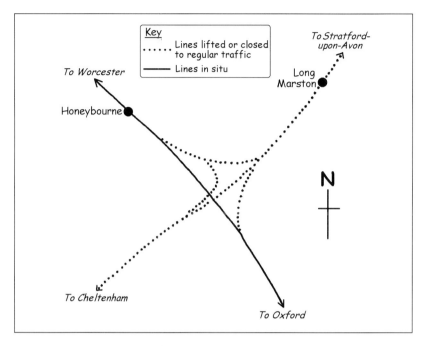

lives on as the offices to a Caravan Club site. The past is not forgotten, however, for the steps leading up to the 'platform' level in the club headquarters are made from old railway sleepers and when caravans arrive they check in at what appears to the visitor to be a covered 'platform' area.

In 1899 the Great Western Railway (GWR) obtained an Act of Parliament allowing the construction of a double-track railway between Honeybourne and Cheltenham and the doubling of a single-track route northwards from Honeybourne to Stratford-upon-Avon. This had the effect of creating a through route from the Midlands to the South West to compete with the loop via Ashchurch and Bromsgrove which survives today.

Work started at the Honeybourne end of the Honeybourne-Cheltenham line in 1902. The following year in November, on 'Friday the thirteenth', there was a serious accident during the course of constructing Stanway Viaduct just north of

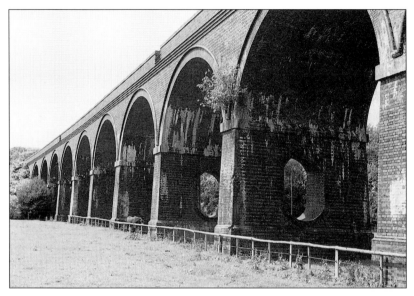

Stanway Viaduct, currently disused, was the scene of a spectacular accident in November 1903 when four arches collapsed during construction, killing four workman. The viaduct will come into use again when Gloucestershire Warwickshire Railway trains eventually reach Broadway. (Author)

Toddington. Gangs of men had been working day and night to complete the work and on the day in question three arches collapsed when supporting frameworks were being removed. The crane driver survived the fall and was sheltering under another arch when this also fell. He was rescued again and was hit by a third arch when this fell forty minutes later. He died that night and there were three other fatalities. The following day a fourth arch fell but by this time steel chains and timber supports had been put in place to save the remainder.

At an inquest verdicts of accidental death were given but a rider was added pointing out that insufficient time had been given for the lime mortar to set before the centres had been removed. The accident also served to underline the problem of employing casual labour without sufficient skills. The man

GWR locomotive no 2246 0-6-0 Collett design (built 1944 withdrawn 1963) stands light in Honeybourne sidings in 1961. Honeybourne station served as an important junction. (D.K.Jones Collection)

operating the crane was actually a butcher trying to earn some extra cash to support his ailing business. When the arches were rebuilt, cement mortar was used.

The line opened as far as Broadway on 1st August 1904 when large crowds at the station greeted the arrival of the first trains. Winchcombe was reached on 1st February 1905 with the remainder of the journey to Cheltenham provided by GWR motor bus. Eventually on 1st August 1906 the line to Cheltenham was completed, three months ahead of schedule. For almost two years a temporary station was used, until work to build a permanent station was finished at Malvern Road, Cheltenham on 30th March 1908. In the same year the doubling of the Honeybourne to Stratford-upon-Avon section was completed.

On 1st July 1908 the new line justified its existence when express services commenced between Birmingham and Bristol, covering the distance in just over 2½ hours. Other through trains

Cheltenham St James station September 1962. St James was built in 1844 as a terminus to the Cheltenham & Great Western Union Railway (for trains from Gloucester, Swindon and Paddington) and sited as close as possible to the town centre. (F.A. Blencowe/R.K. Blencowe)

followed including 'The Cornishman' from Wolverhampton to Penzance, the only named train to regularly use the route. There was also a fair amount of local traffic, particularly during the fruit season. Even in later years, in BR times, the route served as a useful alternative to the former Midland Railway route with its Lickey Incline, a stretch of over 2 miles which rises at 1 in 37½.

During the First World War Cheltenham's High Street and Malvern Road stations closed as a wartime economy measure. High Street never reopened but Malvern Road reopened in 1919. Rail traffic thrived in the 1930s with up to twelve summer Saturday expresses using the line in each direction as well as local and freight traffic. During its life the line had, at one time or another, local stations or halts at Weston-sub-Edge, Willersley Halt, Broadway, Laverton Halt, Toddington, Hailes Abbey Halt, Winchcombe, Gretton Halt, Gotherington, Bishop's Cleeve plus

36

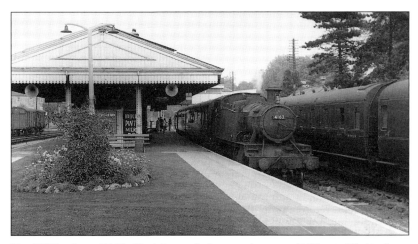

Ex-GWR class 5101 Prairie tank locomotive no 4163 at Cheltenham Malvern Road station, September 1962. The station opened in March 1908 so that through expresses on the Honeybourne line would not have to reverse at Cheltenham St James' terminus. Malvern Road station closed completely in September 1966. (F.A. Blencowe/R.K. Blencowe)

Cheltenham Racecourse, High Street and Malvern Road. In 1948 the GWR was absorbed by British Railways on nationalisation.

Eventually high-speed services between Bristol and Birmingham (on the Lickey line) led to a decline in traffic on the Cheltenham Racecourse to Honeybourne line which closed to local passengers on 7th March 1960. Through express trains continued until the end of the summer 1962 timetable. On 7th September 1962 the last 'Cornishman' express used the route although for a further four years Saturday holiday trains took advantage of the line to reach the South West. A number of stations stayed open for goods traffic and for a time Cheltenham Racecourse station remained in use for race meetings. The road-level ticket office of the Racecourse station which opened in March 1912 had been provided with effective barriers to control a possible crush of passengers leaving the station. The Racecourse station closed officially on 25th March 1968

although it reopened briefly in 1971 for a race meeting.

When the Honeybourne to Stratford-upon-Avon stretch closed to all regular traffic on 5th May 1969, Honeybourne station closed as well. A lot of trackwork remained and the down platform has since been brought back into use for a number of Worcester/Oxford trains. The station is unstaffed and it is a far cry from the days of four platforms and seven signal boxes.

For a number of years BR continued to use the Cheltenham-Stratford route for occasional freight traffic but the end was precipitated on 25th August 1976 when a coal train on the down line became derailed at Winchcombe. The up line remained in use for a short time but it was considered uneconomic to repair the damaged track so BR announced that the Cheltenham to Honeybourne section would close officially on 1st November 1976. No doubt many local folk thought that trains along the Cotswold escarpment would soon be gone for good but they were eventually to be proved very wrong!

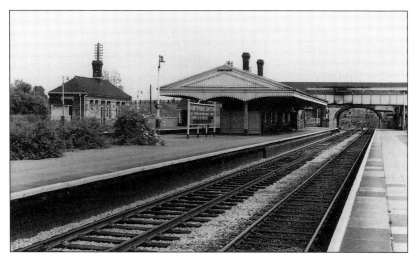

In 1962 the station nameboard at Honeybourne Junction read 'For Stratford-upon-Avon Branch, Warwick, Leamington & Birmingham'. The station closed on 5th May 1969 but reopened in 1981 after considerable lobbying by a large widespread local community. (E.T. Gill/R.K. Blencowe)

38

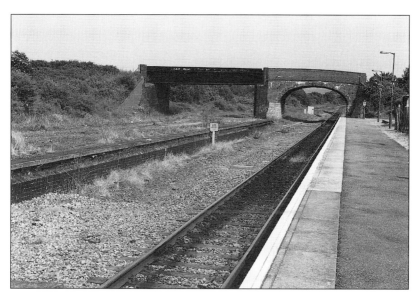

This is all that remains of Honeybourne Junction situated on the 'Cotswold Line' from Worcester to Oxford. The former centre platform is derelict and the near platform serves today's single track line. In the distance beyond the bridge a single track is still in situ curving to the left to a MOD depot at Long Marston. (Author)

Steam returns to Toddington

The Gloucestershire Warwickshire Railway (to become aptly known as the GWR) was formed at a public meeting held at Willersey village hall on 18th August 1976. The object of the meeting was to convince BR that the line should either be retained or run as a private concern. Despite considerable local enthusiasm, closure went ahead so the society paid a deposit to the British Railways Property Board so that purchase negotiations could proceed. However, such efforts were frustrated when at the end of 1976 BR announced the line would remain under 'operational control'.

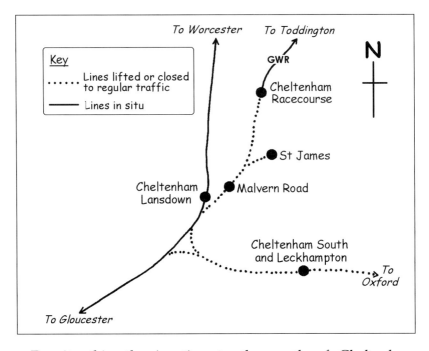

Despite this, the junction to the south of Cheltenham (Lansdown) station was taken out and fishplate bolts along the section were removed. It came as no surprise when, in July 1979, removal of the track by contractors began in earnest, beginning at Winchcombe and working in both directions. It was not long before clearance was complete with many of the stations rapidly becoming derelict. BR still refused to sell, claiming that the line was being held in reserve for possible future use. In August 1980 BR reversed its thinking, saying that due to its financial position the Cheltenham to Honeybourne section could be released although the Honeybourne to Long Marston stretch would be retained.

The GWR lost no time in investigating methods to raise finance and by January 1981 had reached agreement in principle with the British Railways Property Board to purchase the entire trackbed from Cheltenham to Honeybourne and from Long

Marston to Stratford (in all approximately 22 miles) although in the event only the Cheltenham to Honeybourne section was purchased, for £25,000. At the same time the GWR applied through Parliamentary Agents for a Light Railway Order so that passenger carrying could start when this might be possible.

The route to Stratford has been earmarked for possible railway use and, in general, efforts have been made to preserve the former line from encroaching buildings and road schemes. The Stratford and Broadway Railway Society has made its base at Long Marston and aims to protect this part of the once-important through route. The two organisations are co-operating to ensure that this aim may eventually be achieved.

When the first working party arrived at Toddington yard on 28th March 1981 the enormity of the task was well appreciated. The track clearance by the contractors had been so thorough that not a sleeper, fishplate or chair was to be seen. The station at

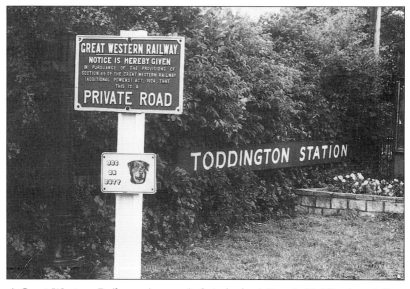

A Great Western Railway sign reminds today's visitors to Toddington station of the days when steam trains were available to Cheltenham Malvern Road or Honeybourne. (Author)

Toddington was in a bad state with the platforms ripped back and replaced by mounds of earth. The building was in use as a store for a garden centre. Equally depressing was the state of the signal box. Only a few days previously the Gwili Railway Society of Dyfed had purchased the lever frames and necessary equipment (negotiated through another BR department) and the box was derelict. The glass had gone from the windows and even the steps had been removed by BR.

Undaunted, clearance of the site began and a few lengths of track were laid. By the end of May the first locomotive arrived – an 0-6-0 Hudswell Clarke D615 diesel of 1938. The first steam locomotive followed during June when a 2-8-0 ex-Great Western Railway Churchward class 2800 no 2807 arrived from Barry. Further engines and items of rolling stock were soon to arrive. On 28th July 1981 the company was formally registered and a

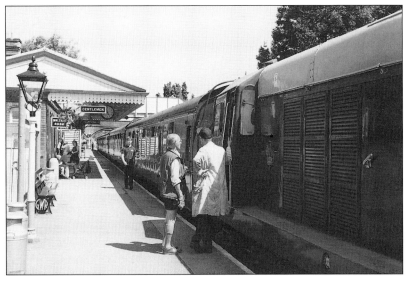

A diesel-hauled train awaits departure from Toddington station, June 2001. This popular preserved railway runs regular services throughout most weekends and bank holidays and on most days during the summer holidays. (Author)

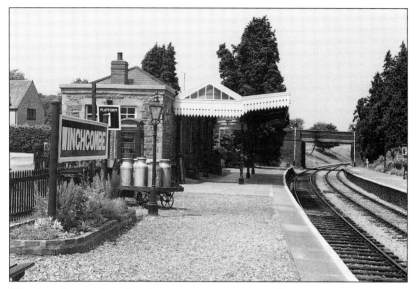

Winchcombe station closed to passengers in March 1960 and to goods in November 1964. Today's building came from Monmouth Troy (closed 1959) and serves trains on the restored Gloucestershire Warwickshire Railway. (Author)

share issue opened. Adequate cash was soon raised enabling the company to purchase further track materials and necessary equipment. A turntable came from BR at Ashford in Kent and four ex-Great Western camping coaches arrived from Dawlish Warren by road.

Toddington station building was completely renovated and the platform reinstated. The signal box was fully restored with new frames and levers acquired from Earlswood Lakes station in North Warwickshire on the Stratford to Tyseley line although when fitted considerable modification was necessary. There was great excitement when standard gauge services began from Toddington over a 700 yard section with a two-coach push and pull train. On Easter Sunday, 22nd April 1984, the stretch was formally opened by local MP, the Secretary of State for

43

The restored Toddington station, June 2001, where Gloucestershire Warwickshire Railway trains run 13 mile round trips to Winchcombe and Gotherington and back. When visited in June 2001 plans were well in hand for services to extend to Cheltenham Racecourse station. (Author)

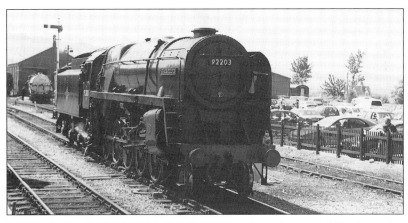

Locomotive no 92203 'Black Prince' runs round coaches at Toddington prior to hauling the 12.15 pm train to Winchcombe and Gotherington. During the journey the train passes through Greet tunnel which at 693 yards is the longest on a UK preserved line. (Author)

Transport, Mr Nicholas Ridley, when a tape was cut. During the first three weekends of operations over 4,000 people visited the site.

A new station was needed at Winchcombe to the south and this came from Monmouth Troy which had closed to passengers in January 1959. To complete the move, every stone, piece of timber and casting had to be meticulously numbered so that the reconstruction could be as near to the original as possible. Similarly Winchcombe's signal box, coming from Hall Green on the North Warwickshire line, had to be moved piece by piece and rebuilt. Winchcombe station was opened in 1987 by John Slatter, Chairman of Winchcombe Council.

Over the following years volunteers steadily restored the line

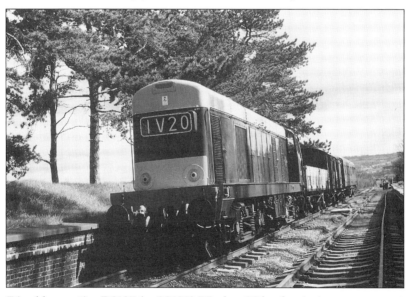

Diesel locomotive D8137 (ex 20137) BR class 20 hauls a train on permanent way duties at Cheltenham Racecourse station on 28th April 2001. The line between Cheltenham and Honeybourne closed to regular passenger traffic in March 1960 but the Racecourse station remained open for race traffic until 1968 although there was special race traffic in March 1971. (Photograph courtesy of Wayne Finch)

History is made when Hunslet shunter 'King George' becomes the first steam locomotive to travel to Cheltenham Racecourse station for over 30 years. The Gloucestershire Warwickshire Railway plans to reopen the station to passenger traffic in 2003 with the ultimate aim that services should be restored between Cheltenham and Stratford-upon-Avon. (Photograph courtesy of Wayne Finch)

southwards reaching Gretton (through Greet tunnel 693 yards long) in 1990 and Gotherington (6½ miles from Toddington) in 1997. In July 2001 Gotherington was the current terminus of passenger services but plans are well in hand to press southwards to provide passenger services to Cheltenham Racecourse station. Track to the racecourse was completed in December 2000 and the first train reached the station on 30th December. It was a permanent way gang's works train hauled by a class 03 diesel shunter. Less than two months later, history was again made when the first steam locomotive travelled the 10½ miles from Toddington to the racecourse. When the Hunslet locomotive *King George* entered the station it was the first steam train seen there for over 30 years. It was welcomed by Edward Gillespie,

46

Managing Director of Cheltenham Racecourse Company with the words, 'What kept you? You're over 30 years late!'

Much work needs to be done before passenger trains can reach Cheltenham Racecourse and considerable funds need to be raised by the purchase of shares. A news release following the opening pointed out that 400 'Dogfish' hopper loads were needed – 8,000 tons of ballast – as well as fencing, drainage work, track clearance plus signalling and telegraph equipment to be installed. The target date for the Racecourse station is April 2003. After Cheltenham, GWR's efforts will be directed towards Broadway and then, who knows, on to Honeybourne? Perhaps one day even Stratford-upon-Avon? Today these may seem pipe-dreams but tomorrow – reality?

The tremendous hard work and enthusiasm that has gone into the Gloucestershire Warwickshire Railway can only really be appreciated by a personal visit. The society can be justly proud of its present wide range of locomotives, coaches and wagons. With such enthusiasm it deserves to succeed.

3
The Severn Valley Railway

Shrewsbury/Bridgnorth/Bewdley/Hartlebury
Bridgnorth/Bewdley/Kidderminster –
a line restored

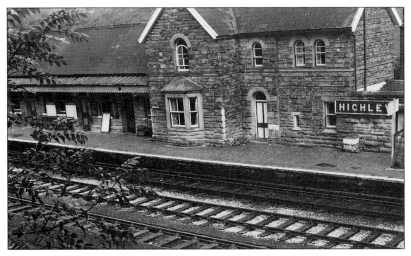

Highley station, a single-platform station, in earlier times. A cattle pen nearby at one time was used for considerable cattle traffic. (Lens of Sutton)

Passengers stood contentedly at Highley station waiting for a Kidderminster train. The attractive location and stone building had changed little over the years since the station first opened to the public on 1st February 1862. Carefully tended flower gardens and hanging baskets enhanced the area and GWR notices gave train times. Nearby an advertisement read 'Craven A will not affect your throat' and at the end of the platform a notice threatened, 'Shut the gate: The Penalty is FIFTY POUNDS for leaving this gate unlocked'.

48

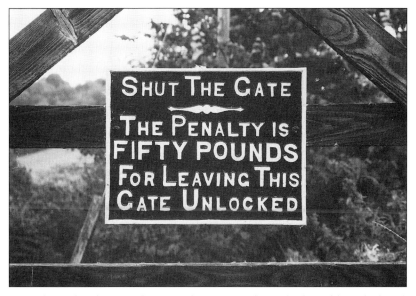

A stiff penalty for not shutting the gate at the end of Highley platform!
(Author)

It was not long before LMS locomotive 4-6-0 class 5 no 45110 known as *Black Five* steamed round the single-track bend into the station hauling numerous chocolate and cream coloured GWR coaches. Soon passengers alighted, others clambered aboard, a whistle blew and the train continued its journey to Kidderminster. Yet this was not the 1950s or even earlier – the date was Wednesday, 1st August 2001 and it was of course a visit to the ever popular present-day Severn Valley Railway (SVR).

Shrewsbury/Bridgnorth/Bewdley/ Hartlebury

Parliament agreed as early as 1853 that the original Severn Valley Railway (SVR) could be built but it was to be another nine

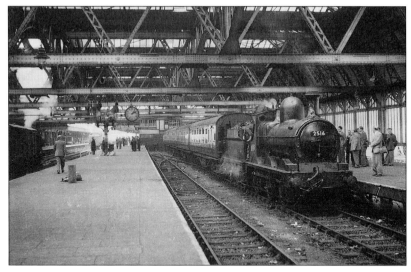

GWR 0-6-0 no 2516 class 2301 awaits departure at Shrewsbury station in the early 1950s. (Lens of Sutton)

years before such a line came into being. When completed it provided a link between the county towns of Worcestershire and Shropshire, providing rail transport to a number of industrial and agricultural areas. Regular services between Hartlebury and Shrewsbury began on 1st February 1862 and they were worked by the West Midland Railway.

The formal opening had taken place on the previous day when a special train of twenty-two coaches had left Worcester Shrub Hill bound for Shrewsbury. The passengers included the chairman of the GWR, the chairman of the SVR and the general manager of the West Midland Railway (WMR). At Shrewsbury three more coaches and an extra locomotive were added, after which the train returned non-stop to Bridgnorth where the various passengers enjoyed a public dinner at the Assembly Room followed by various speeches.

The line of almost 40 miles was single throughout and, although it followed the course of the river Severn, fairly steep

gradients were necessary reaching 1 in 100 in places. Numerous viaducts had been required and tunnels included one of 594 yards at Bridgnorth to take the tracks under the town and another between Bewdley and Stourport 480 yards long. Along the line there were 13 intermediate stations. Most of these had two platforms and a loop although a number began their existence with just one platform and no loop.

The SVR provided four passenger trains each way daily with further services available south of Bridgnorth. There were useful amounts of freight traffic, much of it agricultural and coal traffic coming from the Highley area. To the north there were links at Buildwas with the market town of Much Wenlock and on to Craven Arms on the Shrewsbury & Hereford Railway. Buildwas became a busy junction with its platforms at two levels and the station-master had a staff of ten.

On 18th July 1872 the SVR was absorbed into the GWR which in 1878 opened a link between Kidderminster and Bewdley. This

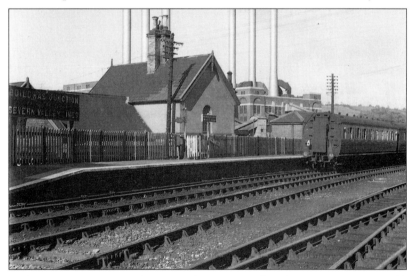

Buildwas Junction on the original Severn Valley line. Passengers could change at Buildwas for Much Wenlock or Wellington. Behind the station the now-demolished Buildwas A power station. (Lens of Sutton)

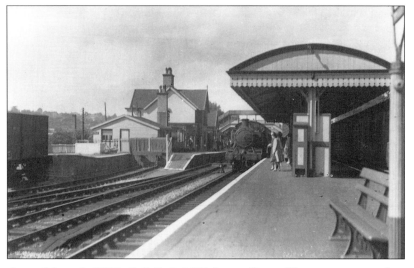

A southbound GWR Collett 2-6-2T locomotive with passenger coaches arrives at Bewdley in the late 1930s. In 1878 a link line was built between Bewdley and Kidderminster which meant trains from Shrewsbury could run directly to and from the Birmingham area. (Lens of Sutton)

meant that trains from Birmingham and the West Midlands could reach the Severn Valley. Bewdley became a crossing point with many Hartlebury trains running northwards to Bridgnorth while many Kidderminster trains continued to run to Tenbury or on to Woofferton.

Throughout its life the SVR was never financially successful although freight traffic made a useful contribution. The agricultural and coal traffic from the Highley area were among the SVR's principal sources of income. By the 1930s, despite increasing competition from the motor car, five trains were running daily from Hartlebury or Kidderminster to Shrewsbury with additional auto-trains covering the stretch to Bridgnorth. As the number of passengers diminished, halts were opened in the hope of attracting further business. Many of the earlier tender locomotives had now gone and passenger trains were hauled by class 4500 2-6-2Ts. Diesel railcars were also making an

appearance. Coal from Alveley Colliery, north of Highley, was generally hauled by class 4300 2-6-0s.

Towards the end of the line's life there was a strange occurrence. According to W. B. Herbert in his book *Railway Ghosts*, a Mr Reynolds saw himself in a premonition standing on the footplate of class 4MT 2-6-0 no 43106 leaving Bridgnorth smoke-box, heading for Bewdley. As the cab crossed the bridge the first full-span cross-beam collapsed onto a green Morris Minor passing underneath and the engine fell onto the road below. After a subsequent similar premonition Mr Reynolds related the incidents to his wife. When yet a further person had a similar premonition, it was decided something should be done.

On examination the suspect bridge was found to have a number of loose rivets as well as serious corrosion affecting one side of the first three cross-beams. The situation was reported and the chief civil engineer imposed a strict speed limit on the bridge. Three months later a new bridge was fitted but Mr

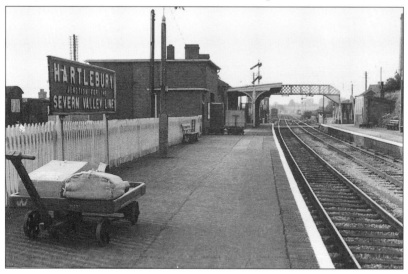

Hartlebury when it served as a junction for Severn Valley line trains to Shrewsbury. Note the tall chimney on the right of the picture. (Lens of Sutton)

Reynolds had further experiences. On one occasion he and his wife saw the vague aura of a human form on the fire-box top of no 43106 and both sensed danger. They called the apparition 'Arnold' and concluded that he was a ghost who liked railway engines and who would appear on occasions to warn of impending accidents!

The Second World War brought renewed activity to the SVR with a large RAF camp near Bridgnorth. After the war traffic dwindled again and neighbouring lines were facing closure. To the north, the Much Wenlock to Craven Arms section closed to passengers on 31st December 1951 and, ten years later on 31st July 1961, the Woofferton to Tenbury stretch closed. Passenger services between Bewdley and Tenbury survived only until 1962, the same year that the line from Much Wenlock to Buildwas and Wellington closed. It was already very clear that the SVR Shrewsbury to Hartlebury route was under threat.

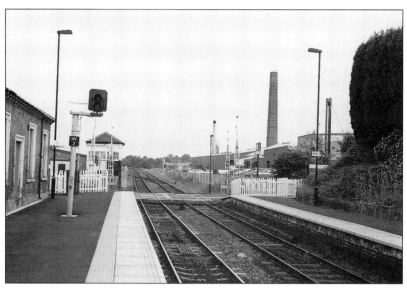

Hartlebury station, June 2001, between Worcester and Kidderminster. The station awning and the footbridge have gone, but the nearby signal box has survived and the tall chimney on the right is still there. (Author)

54

It was a sad day for many when the last regular passenger train left Bridgnorth for Shrewsbury at 7.27 pm on Saturday, 7th September 1963, hauled by class 2 locomotive 2-6-2T no 41207. A coal service between Buildwas and Alveley Colliery Sidings (approximately 1½ miles north of Highley station) closed on 30th November 1963 and when the stretch between Alveley Sidings and Bewdley closed on 3rd February 1969 the colliery's rail link had come to a complete end.

All that was left for passengers was a Kidderminster/Bewdley/Stourport/Hartlebury shuttle. There were strong protests when closure of these lines was announced and a date planned for 7th April 1969 had to be postponed. Eventually when, at 7.20 pm on Saturday, 3rd January 1970, the last train left Bewdley for Kidderminster, it seemed that passenger traffic along any part of the attractive Severn Valley had truly come to an end. Yet this was far from the case. Efforts to restore steam along the SVR had already been in hand for a number of years.

Bridgnorth/Bewdley/Kidderminster – a line restored

The Severn Valley Railway Society was formed on 6th July 1965 when a group of enthusiasts met at Kidderminster. North of Bridgnorth station track had been lifted but, between Alveley Sidings and Bewdley, BR still operated coal trains. The society set out to purchase the 6½ mile disused section from Bridgnorth to Alveley which had fortunately not yet been lifted. The intention was to run passenger trains from Bewdley to Hampton Loade (just over 4 miles) and after two weeks of negotiation a price of £25,000 was agreed with BR to cover all freehold land, buildings and track. A deposit of 10% was paid the following year and within a further three years, after considerable fund raising, the remainder was paid.

There was great excitement when, on Saturday, 23rd May 1970, the first public passenger train left Bridgnorth. Six GWR coaches were hauled by 2251 class ex-GWR locomotive no 3205

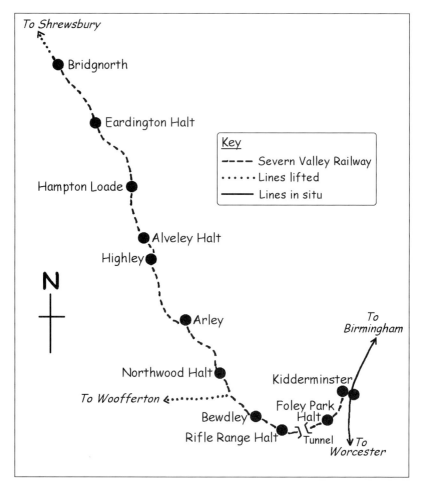

to Hampton Loade and back with an hourly service following. Meanwhile in 1969 Alveley Colliery had closed and SVR members' eyes were already looking further southwards. With Bewdley closed by BR to passengers in January 1970, the way seemed clear to press through Bewdley to Foley Park, near Kidderminster. A further campaign followed, ably assisted by the late Sir Gerald Nabarro, MP for Worcester South since 1961

and also a rail enthusiast. The target of £110,000 was reached and £74,000 was spent on purchasing the railway to Foley Park.

After a tremendous effort by Severn Valley engineering volunteers, Highley was reached in April 1974 with Bewdley following one month later. The final goal of reaching Kidderminster seemed within the SVR's reach but further obstacles had to be overcome. The 2 mile section from Bewdley to Foley Park, although purchased by the SVR in 1974, had been used only on special occasions, such as for steam trains at Enthusiast Weekends. Sugar factory traffic between Foley Park and Kidderminster ceased in 1982 but the line remained available to link BR with the SVR. Eyes turned once again to Kidderminster but problems persisted. BR traffic between Stourbridge and Worcester (via Kidderminster) had become so poor that closure of the section was considered. Happily for the SVR the line was saved when local services between Gloucester and Birmingham

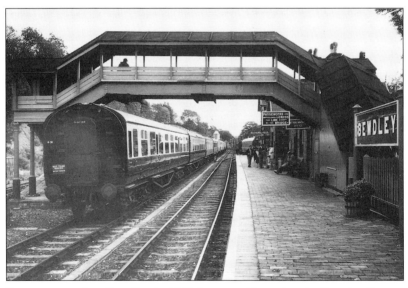

Passengers wait at Bewdley in 1989 for a northbound train. Regular Severn Valley Railway services first recommenced between Bridgnorth and Bewdley on 18th May 1974. (Author)

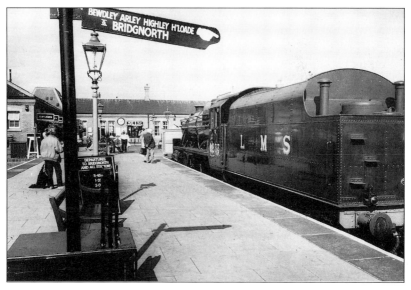

The first SVR train reached Kidderminster on 30th July 1984 and regular services began during December. Ex-LMS 2-8-0 locomotive class 8F no 8233 (photographed at Kidderminster in 1989) has quite a history. Built in 1940 it served in France and later spent time in Iran and then Egypt. It is now renumbered 48773. (Author)

were routed via Kidderminster instead of Bromsgrove, the latter stretch being needed for new High Speed Trains from May 1983.

During 1983/4 over £370,000 was raised by share issue and out of this £75,000 was used to purchase the stretch of line between Foley Park and Kidderminster. The balance was to be used to develop the former BR goods-yard site at Comberton Hill to form a new SVR 'Kidderminster Town' station. Finally on 30th July 1984 the great day came. The first train to enter Kidderminster was a VIP special headed by 4-6-0 no 4930 *Hagley Hall*.

Work to construct Kidderminster Town station buildings began later in 1984 thanks to a grant of £60,000 from the English Tourist Board. It was completed in stages and was officially opened to the public by MP Michael Spicer, Parliamentary

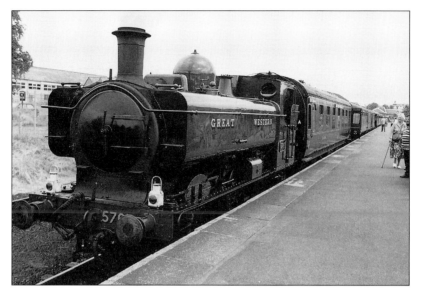

The 11.45 am train from Kidderminster to Bewdley prepares to leave, 27th June 2001, hauled by GWR locomotive no 5764 class 5700 0-6-0PT built in 1929. (Author)

Secretary of State for Transport, on 4th July 1986. The popularity of the new station was undoubted. Situated close to the BR station, the number of passengers using the SVR reached over 190,000 in the first full year at Kidderminster.

Today the Severn Valley Railway continues in popularity, bringing pleasure to the many thousands of visitors who travel the line throughout most of the year. It now has the largest collection of locomotives and rolling stock in the UK, also a significant band of enthusiastic and voluntary supporters. A couple of years ago the SVR celebrated its 30th anniversary. It has come a long way since its modest beginnings in May 1970 when public services first ran between Bridgnorth and Hampton Loade.

4
The Kington Branches
Leominster/Kington/New Radnor
Kington/Presteigne
Kington/Eardisley

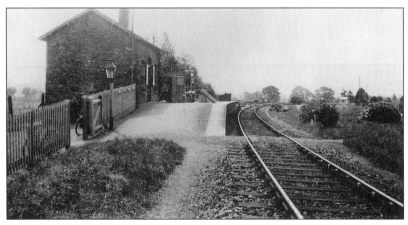

Almeley station on the former Kington/Eardisley line. Almeley closed to traffic in 1917 to reopen in 1922. It closed completely in 1940 during the Second World War. (Lens of Sutton)

When the author visited the village of Almeley, once served by a railway on the former Kington/Eardisley branch, he called at the local public house armed with OS maps and the like and asked where the station was. The publican seemed quite taken aback. 'Was?' he replied. 'It's still there!' He was right, of course, but it was not quite as it had been. The basic building had survived more than 60 years since final closure and ivy and willow grew through the walls and roof. The platform edge was there too but the track had long since gone and the windows were boarded. A number of cows looked contentedly on . . .

This is all that remains of Almeley station where branches sprout from the former station building chimney and cattle can look contentedly on. (Author)

Trains first came to Leominster in 1853 when the Shrewsbury and Hereford Railway Company opened a line between the two towns. By 1863 the company had been absorbed by the GWR and LNWR jointly. During the following year there was a spectacular explosion at the station when the boiler of an engine, 2-4-0 no 108 built by Hicks of Bolton, blew up. The engine, standing in Leominster station, had been hauling the 1.25 am goods train from Hereford and was waiting for permission to continue its journey from the pointsman. Fortunately a few minutes were needed during which time the driver had left his cab. Suddenly the boiler blew up, completely demolishing a small goods shed and subjecting the station house – where the stationmaster and his family were sleeping, luckily at the rear of the building – to a heavy bombardment. Subsequent investigations revealed that a recent overhaul by the Vulcan Foundry had not been satisfactorily concluded.

Visiting Leominster station today, it seems hard to believe that this once comprised four facing platforms built to cater for branch lines to Bromyard and Worcester to the east as well as to

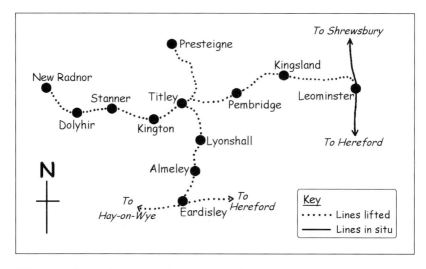

Kington branches to the west. The Leominster & Kington Railway (L&KR) was agreed by Parliament by an Act dated 10th July 1854 although this was not the first 'railway' to reach the area. Limestone quarries existed to the west of Kington and in addition local traders needed an improved outlet for their commodities such as iron, timber and wool. The Kington, Leominster & Stourport Canal had failed and a 3 ft 6 in gauge horse-drawn tramway, opened in 1820, linked with the Hay Railway at Eardisley. Such an indirect route was hardly advantageous and the prospect of a direct rail link with the main Shrewsbury & Hereford Railway was therefore welcomed.

Trains reached Pembridge from Leominster in January 1856 and finally reached Kington on 20th August 1857. Initially there were financial problems for the 13 mile long single track but with Kington becoming an important railhead these were soon overcome as business improved. At one stage, the company's shareholders even received a dividend! There had been ideas that the branch might eventually provide a link between the West Midlands and the Welsh coast but this did not come about.

The furthest west that the Kington branches ever reached was New Radnor and then not until 1875. An extension from

Leominster station on the main line between Hereford and Shrewsbury photographed in the mid-1960s. In earlier times trains left for Worcester or the Kington branches from the far left platform. (Lens of Sutton)

Kington was built by a separate company, the Kington & Eardisley Railway (K&ER). The first section to be opened was a link between Kington and the Hereford, Hay-on-Wye & Brecon Railway at Eardisley with part of the 1820 tramway trackbed being used. This opened on 3rd August 1874 with the K&ER having running rights over the L&KR lines. The junction with the L&KR was at Titley some 2 miles east of Kington. The extension to New Radnor opened over a year later on 25th September 1875 with the new terminus inconveniently sited at the foot of a hill and about half a mile from the village. Kington remained the busiest station with only about half the six trains arriving daily from Leominster going on to New Radnor. Later that same year a short branch opened northwards from Titley to Presteigne (spelt 'Presteign' after 1952). Nearly 6 miles long, it had been authorised in 1871 and it opened on 10th September 1875. In 1897 the GWR, already working the branches, took over the

Kingsland station, c1910. In the early 1920s there were five trains each way on weekdays only between Leominster and Kington with three travelling on to New Radnor. (Lens of Sutton)

K&ER and a year later took over the Leominster branch including its line to Presteigne.

The lines continued over the years, carrying steady passenger traffic and useful amounts of freight. In 1917 during the First World War, the Titley/Eardisley branch closed temporarily but during 1922 it reopened to goods traffic and at the end of the year passenger services resumed. With the branch set in such rural surroundings it was clear it could not last indefinitely and there was no surprise when, due to economies during the Second World War, the line from Titley to Eardisley closed completely on 1st July 1940. The remainder survived until the 1950s. The Kington to New Radnor and Presteigne branch lines were closed to passengers in February 1951 because of coal shortages and the remaining Kington to Leominster regular passenger services were finally forced to a closure on 7th February 1955 when defeated by competition from local buses.

The Kington branch had a last moment of glory when, on 27th

The crossing cottage at Kingsland is today 'Railway Cottage', a private residence. The station closed to passengers on 7th February 1955. (Author)

July 1957, GWR 0-4-2T locomotive no 1455 hauled two coaches along much of the route to celebrate the centenary of its opening. This was an SLS special and the furthest point west that was reached was Dolyhir station.

Over 45 years have passed since closure yet for the enthusiast there are still many relics from the branch line days to be found. Travelling westwards from Leominster within the valleys of the rivers Lugg and Arrow it is possible to see where Kingsland station existed on the A4110. The line crossed the road at this point and after closure the crossing keeper's cottage and station house became private residences. There were also crossing gates operated by the occupants of cottages at Brook Bridge and Waterloo. Freddie Fox, the notable flat race jockey, was born at the latter and it was there that a unique 3½ mile aerial railway existed to carry timber for pit props to the local saw mills.

Some 3 miles further on Pembridge station building has sur-

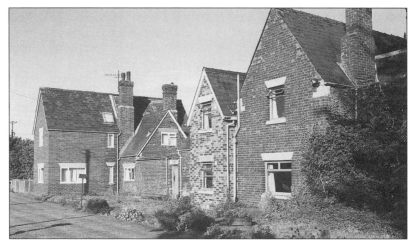

Pembridge station between Leominster and Titley closed to passengers in 1955 and goods in 1964 to become private residences. The station signalman lived in the end property and spent his entire life there! (Author)

A reminder of Pembridge station survives to this day with this distant signal erected in the garden and visible to all passers-by. (Author)

vived to the north of the village as a private residence. This is easier to find for a 'distant' signal stands in the garden (not in its original location). The signal had been installed by the local signalman who had lived in this one property all his life. There was a keeper's cottage where Marston Halt existed but the owner of the private residence currently built on the site told the author it had burnt down some years back. Marston Halt had consisted of a single wooden platform and a small primitive shelter. Such was its isolation that the guard of the last train of the day was expected to extinguish the platform's oil lamps!

Titley station was sited in a remote setting some way from the village. Although restored, this is today a strictly private residence. Kington's original station building of 1857 exists to the east of the town on an industrial estate. This well-maintained Victorian building, now a private residence, carries a plaque commemorating the event. When a bypass was built in 1983 the trackbed between the town and Stanner proved useful with the cutting close to the river Arrow being deepened and widened.

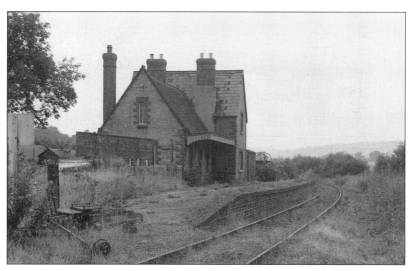

Titley station some years after its closure in 1959. The property is today a strictly private residence. (Lens of Sutton)

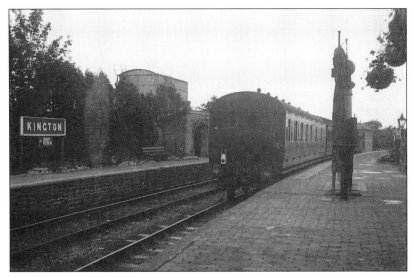

Kington station between Titley and New Radnor which closed to passengers in February 1955. The station area is today part of an industrial estate. (Lens of Sutton)

There were two intermediate stations along the 8 mile line between Kington and New Radnor. Stanner was another station in isolated surroundings and situated close to the foothills of Radnor Forest. Apart from a small stone building on a solitary platform, a nameboard and the familiar GWR fencing, that was it. Stanner closed to passengers in 1951 but, like Dolyhir, it remained open for occasional freight traffic until 1958. It was Dolyhir's limestone quarries that, towards the end, helped to keep the line open. New Radnor at the end of the line was equally insignificant as a station although it possessed a run-round loop and a siding. After closure it became a caravan park yet had that line through to Aberystwyth ever been built perhaps the station might still be there.

Northwards from Titley a single track reached Presteigne. The initial terminus was near the town's jail but this was later resited nearer the town centre. It was expected that the railway might

68

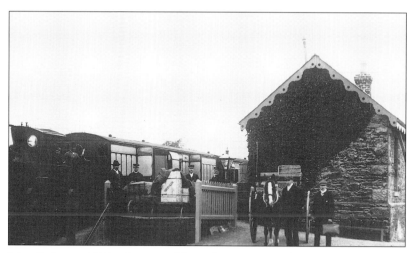

New Radnor, c1910, when travel from the station was by horse and cart. The station closed in 1951. (Lens of Sutton)

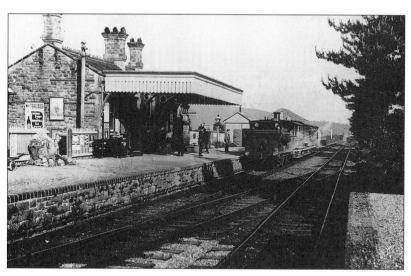

A mixed freight and passenger train arrives at Presteigne. In the 1920s four trains daily on weekdays reached the terminus by a shuttle service from Kington via Titley. The journey took roughly 20 minutes. (Lens of Sutton)

boost the town's prosperity but this did not happen. Like the New Radnor line it closed to passengers in 1951 but lasted for freight until 1964. The only intermediate station was Forge Crossing Halt which had opened in 1929. The keeper's cottage is today in private use. At Presteigne an industrial estate has been developed on the station site and to the south a section of trackbed has been converted to a road with a junction built where the B4362 meets the B4355.

The Kington & Eardisley branch had two intermediate stations south of Titley. The first was Lyonshall, a station built on an embankment with part of the platform on a road bridge. After the station had closed to all traffic in July 1940 the rails were taken up and used elsewhere. The bridge too was taken out, effectively cutting the station in half. Today the station building is a private residence and the nameboard 'Lyonshall' is still there. There is a local tale that ghostly footprints are sometimes

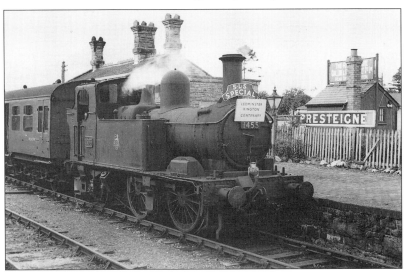

Stephenson Locomotive Society members visit the terminus of Presteigne in 1955. The train is hauled by GWR locomotive no 1455 0-4-2T class 1400 (Collett design, built 1935 and withdrawn 1964). Presteigne closed to passengers in 1951. (Lens of Sutton)

70

found on the steps leading up to the old station . . . Opposite Lyonshall village church on the main Kington to Leominster road can be found a row of cottages known as 'The Wharf' where the horse-drawn trams passed earlier last century.

Eardisley was where the Kington branch joined the Hereford, Hay and Brecon line which closed to all traffic in 1964. After traffic ceased, the station, sited to the east of an overbridge on the A4111, had various uses. The former waiting room was used for a time as a piggery! In August 1991 work began to dismantle the station building piece by piece and painstakingly re-erect it at the Welshpool & Llanfair Light Railway's terminus at Raven Square, Welshpool. The work was completed when the building reopened on 17th April 1992.

In the village of Eardisley, on the A4111, there is a public house called the Tram Inn where the sign recalls the days when coal was carried from Brecon to Eardisley in horse-drawn wagons and later to Kington (see also chapter 8). There is a story in *The Herefordshire Village Book* (publisher: Countryside Books) which tells that, during the Second World War, fox pie was served at the pub. The claim came from the German radio propagandist Lord Haw-Haw who said in a 'news' bulletin that the starving English were being driven to partake in such dishes!

5
Lines Meet At Tenbury Wells

Woofferton/Tenbury Wells/Bewdley

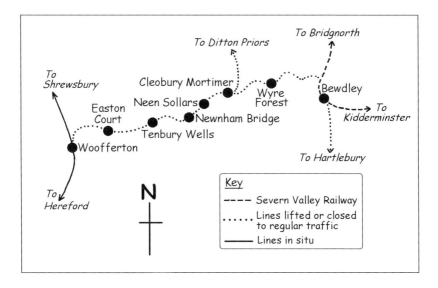

The Kington, Leominster and Stourport Canal was an ambitious project intended to open up a route to the river Severn as well as the industrial Midlands. Three large aqueducts, four tunnels (with one over 2 miles in length) and some 16 locks were planned, although in the event only a stretch of some 18 miles of continuous waterway, from Leominster to just beyond Newnham, was completed. The section cost £93,000 to build but it did not prove successful and no dividend was ever paid to shareholders.

Two miles from Newnham close to the present A456 the 1,250

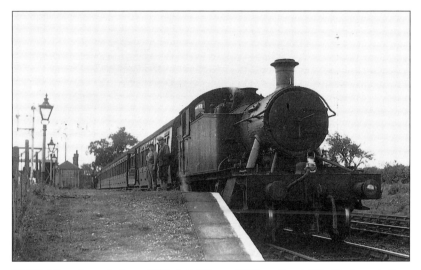

GWR Churchward class 4500 2-6-2T no 4596 waits at Woofferton station probably in the late 1940s. The station closed to passengers in July 1961. (Lens of Sutton)

yard long Southnet tunnel was built. It was completed in 1795 but it collapsed in the same year and, according to local rumours, two men and a boat are still entombed there! There was a proposal that the remainder of the journey to Stourport should be completed by tramway but this did not come about. What existed of the canal struggled through the first half of the 19th century to be eventually sold to the Shrewsbury & Hereford Railway (S&HR). The canal closed for good in 1859 and in the same year the Tenbury Railway Company (helped by the S&HR) was incorporated.

The single-track railway between Woofferton and Bewdley crossed the county boundaries of Worcestershire, Shropshire and Herefordshire several times during its run through attractive and unspoilt countryside. The first section between Woofferton and Tenbury Wells opened on 1st August 1861 and was worked by the GWR. Tenbury Wells remained a terminus for only three years, after which time the Tenbury & Bewdley

73

Railway, incorporated in 1860, completed the section to Bewdley. This was also GWR worked and it opened on 13th August 1864.

Two companies now existed but the lines were soon integrated into one long branch although a few trains did continue to run between Woofferton and Tenbury only. In June 1878 a 3 mile link between Bewdley and Kidderminster opened which meant that through trains were possible not only from Woofferton to Kidderminster but also for a time there were through connections between Woofferton and Birmingham and Wolverhampton.

According to a letter published in *Railway Magazine* in the 1930s there was once a time when the name Woofferton was spelt correctly on the nameboards, yet on the signal box it read 'Wofferton' and the platform trolleys read 'Wooferton'! Leaving Woofferton station, the branch bore sharply eastwards along the Teme Valley, stretches of it being built along the abandoned Leominster Canal.

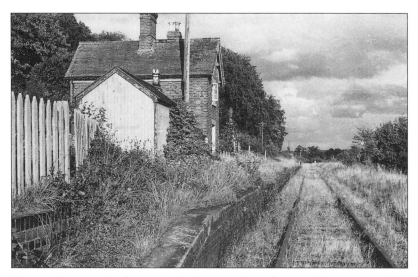

Easton Court station between Woofferton and Tenbury Wells seen here after closure. The station building is today a private residence. (Lens of Sutton)

74

The first intermediate station was Easton Court which was known as 'Easton Court for Little Hereford'. The timetable did not reveal that Little Hereford was half a mile away. Easton Court closed to passengers only a year after opening but reopened three years later in April 1865. Despite the sparsely populated locality the station house was a substantial building and this has survived today as a private dwelling. There was once an aqueduct at Little Hereford which carried the Leominster Canal over the river Teme but, much to the annoyance of the local folk, this was blown up during the Second World War presumably to prevent its use by possible invaders!

In the 1840s Tenbury Wells had become established as a small spa following the discovery of saline springs in the area. Tenbury Wells station was in fact situated in Burford, about half a mile from Tenbury, which lay to the south across the Teme. Burford was the seat of Lord Northwick who with a number of local landowners had done much to get a railway into the area.

Tenbury Wells station opened in August 1861 as a terminus for trains from Woofferton. Three years later a line reached Tenbury Wells from Bewdley. Both were GWR worked. (Lens of Sutton)

75

Tenbury Wells station had two platforms, a number of goods sidings and, in earlier years, a turntable. For a time it had two signal boxes but its West Box closed in the 1920s. The station was initially known as just Tenbury but in 1912 it was renamed Tenbury Wells.

In the early 1920s the branch saw five trains each way daily (none on Sundays) between Kidderminster and Woofferton although a further five made the daily 12 minute journey between Tenbury Wells and Woofferton. Various tank and tender locomotives were used on the line and when traffic was sparse it was not unusual to see an engine hauling a single carriage. In later years GWR diesel railcars were used for many of the passenger services. During the Second World War there was an increase in traffic when considerable quantities of ammunition were carried to and from the Cleobury Mortimer to Ditton Priors branch line.

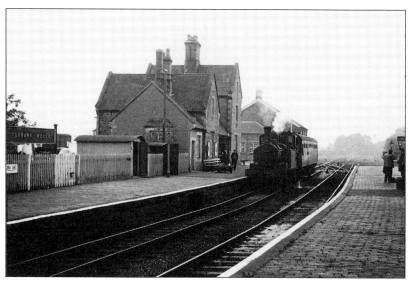

Locomotive 0-4-2T no 1445 hauls an auto train at Tenbury Wells on 7th October 1960. After complete closure in 1964 the station was demolished to become an industrial estate. (D.K. Jones Collection)

After the war traffic suffered from road competition yet a proposal from British Rail on 31st July 1961 to close the entire line to passengers was strongly resisted. Closure of Woofferton station and the withdrawal of all traffic between Woofferton and Tenbury went ahead and Woofferton station was subsequently demolished. However, BR did agree to provide an experimental passenger service between Tenbury and Bewdley comprising a weekday morning train and a return train in the evening. This service survived only a year, ending on 1st August 1962. Goods services lasted a further two years, terminating between Tenbury and Cleobury Mortimer in January 1964 and the final stretch between Cleobury Mortimer and Bewdley ending early in 1965. After closure Tenbury Wells station was totally demolished and the site developed as an industrial estate although a road bridge still exists.

Enter a shop just up a short drive off the A456 at Newnham Bridge and you are in what was once the station building.

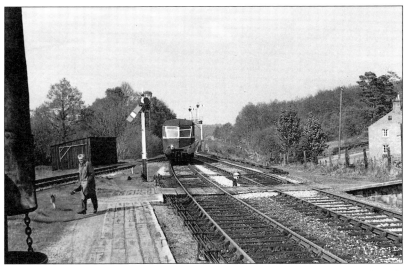

A GWR diesel railcar W14 leaves Cleobury Mortimer in 1955. Fitted with two 105 hp motors, these cars were built in the mid-1950s. (D.K. Jones Collection)

77

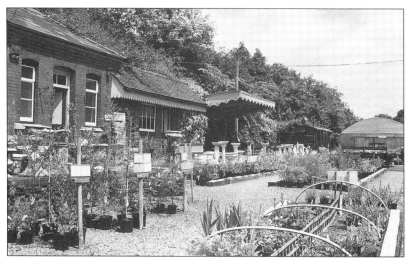

Newnham Bridge, an intermediary station on the Tenbury to Bewdley line, photographed June 2001, some 38 years after closure. The station has been preserved as part of the 'Station House Nursery'. (Author)

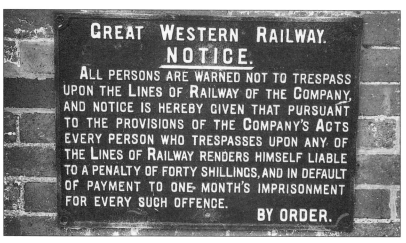

A reminder from GWR days on the wall of the preserved Newnham Bridge station building. During its heyday this was a busy station particularly when fruit was in season. (Author)

Neen Sollers' former station building between Tenbury Wells and Cleobury Mortimer can still be found near the small village and in an isolated area. The station closed completely in 1964. When visited in June 2001 work to restore the building was in hand. (Author)

Outside part of the station yard has become a garden centre. The platform and building remain intact but the station nameboard has been copied. To add further realism a signal and a truck are to be found at the end of the platform, both of which were acquired from the Birmingham area. Originally the station had a signal box but it was later replaced by three ground frames. The single platform was so sited that access from the road had to be made over the track and strict instructions had to be issued to avoid the possibility of vehicles obstructing the running line. At times Newnham Bridge proved a busy station particularly when fruit was in season.

Beyond followed Neen Sollars, a minor station in a very isolated area, which after closure survived as a private dwelling. Next came Cleobury Mortimer, sited about a mile and a half east

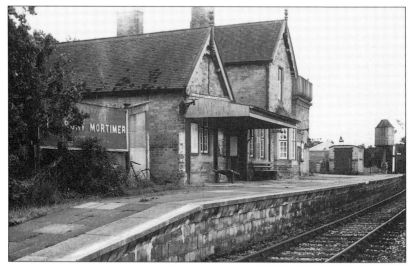

Cleobury Mortimer between Tenbury Wells and Bewdley also served as a junction to the Cleobury Mortimer & Ditton Priors Light Railway. The station was situated about a mile and a half to the east of the town which meant that many passengers had to face a long and hilly walk. (Lens of Sutton)

of the town. Here the track layout was altered when the Cleobury Mortimer & Ditton Priors Light Railway opened in 1908. The remains of Cleobury Mortimer station can be found just to the south of the A4117 up a short drive by the Blount Arms. The station building is today private flats and notices on the wall and doorways recall when trains once called.

The last intermediate station before meeting the SVR at Bewdley was Wyre Forest where much of the track wound its way through heavily graded curves. This small and no doubt little-used station closed with the line in 1962 and today, difficult to find on a minor road, the station building and platform have survived as an attractive private residence. Outside by the road-way can be seen a discarded sleeper with a chair in situ and along the platform a concrete post which once supported fencing now proudly supports a bird box.

Between Wyre Forest station and Bewdley the trackbed passes through the Wyre Forest Nature Reserve which is well worth a visit. Striking out from the visitor centre which can be found on the A456 two miles west of Bewdley, several designated walks can be taken where the forestry blends splendidly with the wildlife and where much of the area is also a Site of Special Scientific Interest. Walking on a little further it is possible to find the trackbed as it winds through the forest alongside Dowles Brook. This leads towards where the three-span Dowles Viaduct once carried trains over the river Severn to join the track of the SVR and on to Bewdley.

6
A Branch To Ditton Priors

Cleobury Mortimer/Ditton Priors

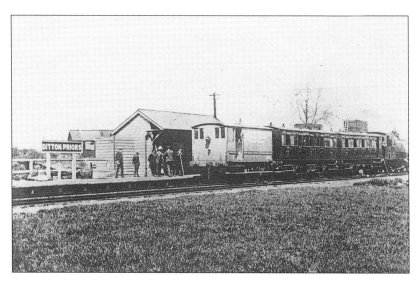

Passenger services on the Ditton Priors branch commenced on 21st November 1908 when two mixed trains ran on certain weekdays only. Picture taken at Ditton Priors terminus. (Lens of Sutton)

As far as passengers were concerned, the Cleobury Mortimer & Ditton Priors Light Railway (CM&DPLR) lasted only 30 years. Although the last regular passenger train travelled the line on 26th September 1938, another 27 years were to pass before the line closed completely.

An Act agreeing a Light Railway from Cleobury Mortimer to Ditton Priors was granted on 23rd March 1901 yet it took some seven years before the line of nearly 12 miles could open. There were financial problems and it was not until March 1906 that a

tender was accepted. On 23rd January 1907 the first sod was cut, although without any ceremony. Work commenced two days later and in June 1907 a connection was made with the GWR line at Cleobury Mortimer. The line opened to freight traffic on 19th July 1908 and a daily goods train initially hauled by contractor's locomotives was possible. Passenger services commenced on 21st November 1908 after a Board of Trade inspection of the line had been completed. At first two mixed trains ran on certain weekdays only each way. Manning Wardle 0-6-0ST locomotives 1734 and 1735 named *Burwarton* after Lord Boyne's estate and *Cleobury* were available together with four four-wheeled oil-lit coaches. The latter were purchased from Bow Works in London being conversions from North London Railway coaches.

The line was built principally to provide a rail outlet for stone quarried on the adjacent Clee Hills. Much of the stone came from the Clee Hill Granite Company's Magpie Quarries on

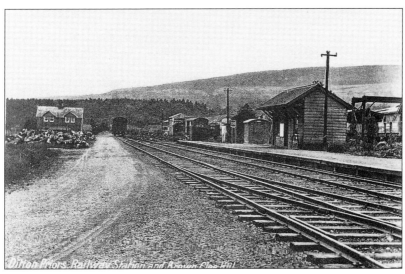

Ditton Priors station soon after its opening in 1908 with Brown Clee hill in the background. The branch of nearly 12 miles opened to provide a rail outlet for quarried stone. (Lens of Sutton)

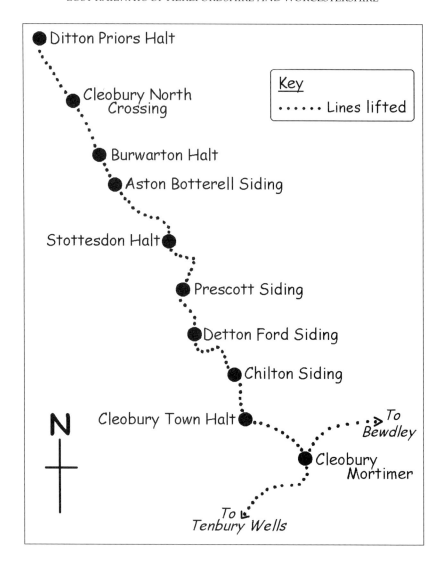

Titterstone Clee Hill and it was carried by means of a 3½ mile aerial ropeway which reached the railway at Detton Ford Siding. Another quarry on Brown Clee Hill (1,792 ft) was operated by the Abdon Clee Stone Quarrying Company where stone was brought down a rope-worked incline to connect with a siding at Ditton Priors. There was a considerable demand for the stone particularly in growing urban areas where, prior to 1914, it was used to produce 6 in by 9 in tramway setts.

The CM&DPLR began its life with great hopes for the future. Freight from the quarries brought considerable business with both the GWR and the Midland Railway bringing in their wagons. Occasionally passenger trains connected with Kidderminster where the market was popular and in August 1909 many travelled by rail to attend an Industrial, Horticultural and Poultry Show at Burwarton. On that occasion the line's capacity was stretched to its maximum when 300 extra passengers were catered for in one day. In 1910 some 15,000 passengers and 77,000 tons of freight were carried and in 1911 the operating surplus almost doubled.

Because of the surge in popularity consideration was given to extending beyond the existing branch. Proposals for a 'Stottesdon, Kinlet and Billingsley Light Railway' as a means to bring coal from collieries both at Billingsley and Kinlet to join the CM&DPLR at Stottesdon came to nothing. Coal from the Billingsley colliery was eventually carried by mineral line to join the SVR between Highley and Arley. There was also speculation that the line might extend beyond Ditton Priors to Presthope to join the Craven Arms/Buildwas line or the Severn Valley branch at either Bridgnorth or Coalport but again nothing happened.

In the couple of years leading up to the First World War passenger traffic fell disappointingly, a situation hardly surprising in such a rural area. Yet soon after hostilities had begun in 1914 freight traffic improved considerably. Stone from the quarries found new customers and quantities were railed regularly to Aldershot. Wagons were soon in short supply and many more were acquired. The GWR lent class 850 0-6-0PT locomotive no

85

2001 to the CM&DPLR for a time to help out. As the war progressed freight traffic in timber also increased.

The wartime period also saw the development of prefabricated buildings at the Abdon Clee Stone Quarry. Sections were made using the right mix of cement and stone and it was intended the system should be used on many types of construction. A number of local buildings were erected in this way including a new village hall at Ditton Priors. In the same way the railway company's offices at Cleobury Town were prefabricated.

After the war in 1919 the two locomotives, having now served over 10 years faithful duty, took turns to go away to Worcester for repairs. In the same year 'peace' celebrations took place and to mark the event the Abdon Clee Quarry managing director treated his employees and all in the parish to a lavish tea. On 19th August 1921 the 'Railways Act' became law, this requiring the railways of Great Britain to be merged into four groups. In consequence, the CM&DPLR on 25th May 1922 became part of the Great Western Railway.

The locomotives 1734 *Burwarton* and 1735 *Cleobury* therefore became GWR stock but they were renumbered nos 28 and 29. The GWR decided that they justified an extensive rebuild so in 1930 they were both sent to Swindon. During their absence, 8650 class 0-6-0ST no 1948 and 0-6-0ST no 1970 were delivered from Kidderminster to keep the branch going. Both *Burwarton* and *Cleobury* were eventually returned to the branch rebuilt as pannier tank locomotives. Early in 1926 the four North London Railway coaches were withdrawn and in their place came GWR gas-lit four-wheeled coaches.

Passenger traffic continued to decline. In a GWR timetable of the 1920s it was pointed out that stops would only be made at some stations 'if required'. By the early 1930s the quantities of stone carried had dropped considerably and traffic along the line was reduced to two mixed trains daily. Closure to passenger traffic became inevitable and soon closure notices were displayed. Even so, petitions were organised to keep the line working but these had no effect. When the last passenger train

Manning Wardle 0-6-0ST 'Cleobury' with brake van no 2 at Ditton Priors. 'Cleobury', built in 1908, was taken over by the GWR in 1922 when it was renumbered 29. In 1930 it was rebuilt as a pannier tank locomotive. (Lens of Sutton)

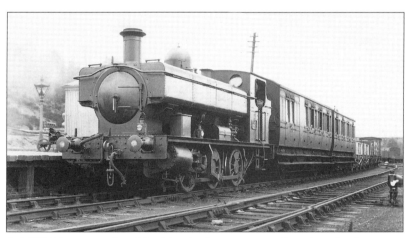

0-6-0PT 'Burwarton' no 28 with mixed passenger and goods waits departure at Cleobury Mortimer station. Coaches were four-wheeled throughout the branch's existence. (Lens of Sutton)

'Cleobury' no 29 hauls a mixed train in the 1930s. The line closed to passengers in September 1938 but survived for goods traffic until April 1965. (Lens of Sutton)

Burwarton station in earlier times. It was little used and it became a 'halt' in 1923. The station was in fact closer to the village of Charlcotte than Burwarton. (Lens of Sutton)

ran on Saturday, 24th September 1938 so many people turned up that two extra four-wheeled carriages had to be added to the two already in use.

Yet as the passenger traffic ceased, so freight traffic received a dramatic boost. As a result of the 1938 Munich crisis, arms were being produced and the CM&DPLR area was considered safe for ammunition storage. Nissen huts were built along the line in readiness and, when hostilities began in September 1939, no 29 was sent to Worcester Works so that a spark arresting cowl could be fitted to her chimney. At first this was to protect ammunition vans from occasional sparks thrown out from the locomotive when tackling a gradient but later it was needed as a protection when working in the armament depot. The area was subsequently selected by the Admiralty as a naval armament depot.

The one-time quiet branch was now a place of activity with the depot assuming strategic importance. Sturdy locomotives

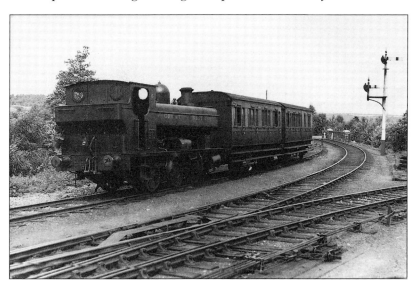

GWR 0-6-0PT no 29 waits with coaches in a siding at Cleobury Mortimer station in 1935. The line played an important role during the Second World War when ammunition was stored in the area. (John H. Meredith)

were brought in to handle the heavy loads over the numerous steep gradients. In their informative book *The Cleobury Mortimer and Ditton Priors Light Railway*, W. Smith and K. Beddoes wrote that the depot even got a mention from the German wartime propagandist Lord Haw Haw. Searchlights were installed at several places along the route and decoy fires were set up on the nearby Clee Hills. Happily the depot remained intact throughout the war with the nearest bombs being dropped near Cleobury Town (at Walltown Farm).

After peace returned in 1945 the line gradually ran down again. Nationalisation came in 1948 with the line coming under BR's Western Region. No great changes were made except that no 29 had a new cowl fitted and no 28, after a short stay on loan at Hereford, returned via Worcester with a new chimney. No 28 later had a spell shunting at NCB Hafod Colliery at Wrexham. Meantime freight traffic along the CM&DPLR branch continued at a fairly leisurely pace with sometimes only one journey per week.

Some 17 years after closure to passengers, 21st May 1955 proved to be a day of some significance for the branch when a Stephenson Locomotive Society train ran from Birmingham via Kidderminster and Bewdley to Ditton Priors. The four-coach train arrived at Cleobury Mortimer hauled by Dean 0-6-0 no 2516 (later preserved at Swindon) where 0-6-0PT class 2021 no 2144 fitted with spark arrestor took over. The train, the first passenger bogie-stock ever to cover the line, travelled as far as Cleobury North sidings before returning.

In May 1957 the Admiralty took over ownership of the line and five months later it took over operation with two Ruston and Hornsby 0-4-0 diesel shunters providing the occasional haulage power. In August 1962 the line between Bewdley and Tenbury Wells closed to passenger traffic and closure of the Ditton Priors branch by the Admiralty seemed inevitable. Eventually all traffic ceased on Good Friday, 16th April 1965, the same day the line from Cleobury Mortimer to Bewdley also completely closed.

Lifting of the track was delayed by removal of Admiralty

equipment by rail from the depot. When track demolition began in earnest later in the year, suggestions were made that the line should be preserved but the difficulties appeared too great and the idea was dropped. Two years later local residents were surprised to read in their newspapers about a report in the House of Commons that the line might be 'reopened to serve a new American army base at Ditton Priors'. The Americans may have moved in but the railway had already gone! Many of the rails and sleepers had been taken up and some of the land had been sold. The Americans stayed at the depot for only 18 months.

When visiting the area in 2001 the author found numerous relics to recall the earlier days. At Ditton Priors, the former terminus and today a trading estate, two water tanks can be seen adjacent to the former platform and nearby stands a row of railway cottages. Many of the buildings on the estate remain as

Ditton Priors station area is today a trading estate. The water towers used by the railway are still there, also numerous buildings that housed naval personnel. (Author)

This is all that remained of Aston Botterell platform and siding when photographed in September 1989. During its life it was little used and today there is nothing to be found. (Author)

reminders of the time when naval personnel were billeted in the area which served as an armament depot during Second World War days. Travelling the branch southwards there was very little to be found. The numerous wooden built halts had long since disappeared. Just off the B4363 the prefabricated Cleobury Town station concrete railway office built in 1917 was still there as a private residence. An old buffer stop helped form part of an end wall to a nearby garden shed.

As mentioned in the previous chapter, the station building and platform edge at Cleobury Mortimer (near the Blount Arms) have survived. For many years after closure the station's nameboard stood amongst the weeds stating 'Cleobury Mortimer. Change for Ditton Priors Railway'. A short distance away stood a bridge which carried the branch over the Bewdley-Cleobury Mortimer road. After final closure of the line the army

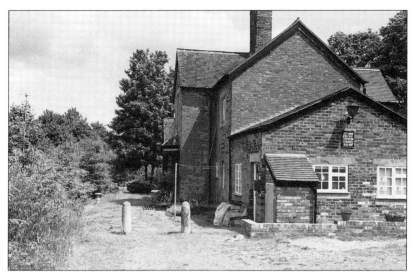

Recollections of railway days remain at the former Cleobury Mortimer station building. Today private residences, doors carry name plates from the past. (Author)

A close-up of a sign on the wall of the former Cleobury Mortimer station building. The station closed in August 1962 to passenger traffic but lingered serving goods traffic between Cleobury Mortimer and Bewdley until April 1965. (Author)

was called in to blow it up. According to local legend, a pot of gold sovereigns had been bricked in when the bridge was built, yet no trace was found. When the author visited the remains of the abutments in 2001 he had a poke around in the undergrowth – just in case.

7

Westwards From Worcester

Worcester/Bromyard/Leominster

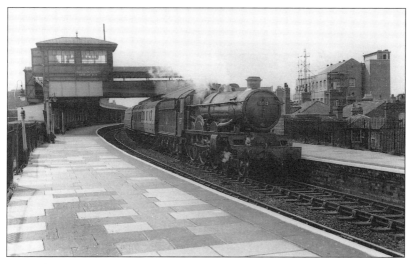

GWR locomotive no 5012 4-6-0 Collett design Castle class at Worcester Foregate Street station in the 1950s. Locomotive 5012, named 'Berry Pomeroy Castle' was built in 1927 and withdrawn in 1962. A line between Hereford and Worcester opened on 17th September 1861. (R.K. Blencowe)

When Parliament agreed a railway from Worcester to Leominster via Bromyard on 1st August 1861 it was hardly thought that it was to take another 36 years before the line was completed. The Worcester, Bromyard and Leominster Railway Company had as its chairman Sir Charles Hastings, founder of the British Medical Association, but this did little to expedite matters. Eight years later in 1869 the promoters, probably reconsidering the sparseness of the route, abandoned the 12 mile Leominster-Bromyard stretch.

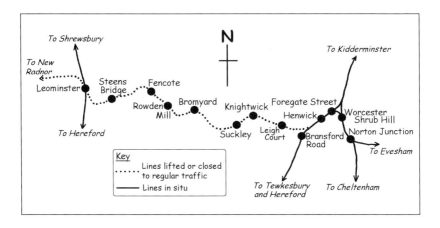

In 1870 the GWR came to the rescue over the remaining distance by agreeing to work the section from Bransford Road junction (on the Worcester & Hereford line and to the north of Bransford Road station) to Bromyard. This opened on 2nd May 1874 although only reaching as far as Yearsett where a temporary terminus was established. It took another three years before Bromyard was reached and when this 3¾ mile stretch opened on 22nd October 1877, Yearsett station was closed. It is thought that Yearsett had the shortest life of any GWR station!

Meantime plans for the abandoned Leominster to Bromyard Railway had been revived by an Act agreed in July 1874. Another ten years passed before part of the line opened and then only a 4 mile stretch from Leominster to Steens Bridge, the latter built as a simple one-platform terminus with a run-round loop. The two sections remained isolated for another 13 years during which time, on July 1st 1888, both companies were acquired by the GWR. Finally on 1st September 1897 the whole line was complete. When Steens Bridge was linked with Bromyard, trains could at last travel directly from Leominster to Worcester.

The through opening meant considerable alterations at Bromyard where two platforms were now needed although it was possible to utilise a section of the existing building as part of

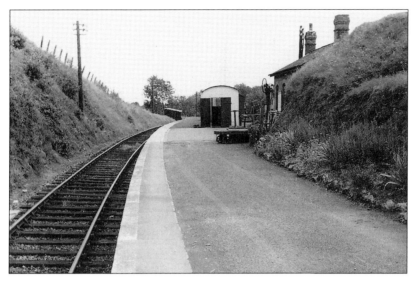

Knightwick station's single platform in the early 1960s. After closure the station building was converted to a private residence. (R.K. Blencowe)

the enlargement. Since Bromyard was no longer a terminus, the small engine shed was closed and demolished. Between Bromyard and Steens Bridge two stations were added, these being Fencote and Rowden Mill. Despite the remoteness of its surrounding area, Fencote acquired two platforms, a crossing loop and a signal box whereas Rowden Mill had to be content with just one platform for the single-track line.

Intermediate stations between Bromyard and Bransford Road junction were provided at Suckley, Knightwick and Leigh Court. These were also single-platform stations although Suckley acquired a second platform, a crossing loop and a signal box earlier last century. At Worcester the trains used Shrub Hill station as their terminus, calling at Foregate Street on the journey. Since any population along the line was almost non-existent, passenger traffic was never heavy. The journey time between Worcester and Leominster took almost 1½ hours to cover the 27½ miles.

Throughout much of the line's life, there were five trains daily in each direction with no service on Sundays. In *Bradshaw's Railway Guide* of July 1922 the first up train left Leominster at 7 am each morning calling at all stations and arriving at Worcester (Shrub Hill) at 8.25 am. The first down train of the day left Worcester at 8.15 am to reach Leominster at 9.33 am. Each way trains had a few minutes wait at Bromyard. In 1929 Stoke Prior Halt was opened between Leominster and Steens Bridge and in 1932 three trains were running on Sundays between Worcester and Bromyard.

The line was generally worked by class 517 0-4-2T locomotives with 0-6-0STs used for freight. In later years more modern locomotives were introduced and on occasions a diesel railcar

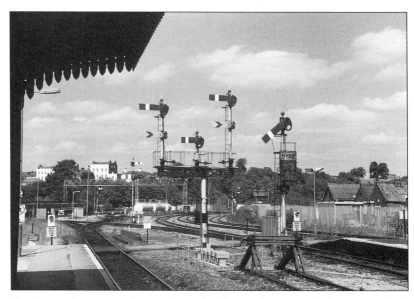

An impressive array of semaphore signals can be seen at Worcester Shrub Hill station (August 1999). Tracks to the left leave for Worcester Foregate Street and to the right towards Birmingham. In earlier times trains left regularly via Foregate Street and Bromyard to Leominster. (Photo courtesy of Colin Jenkins)

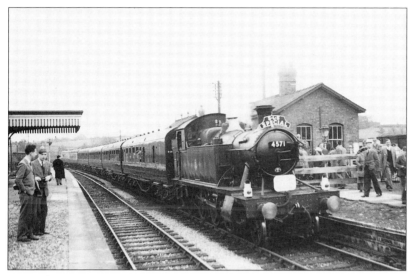

GWR locomotive no 4571 2-6-2T Churchward design class 4500 hauls a special organised by the Stephenson Locomotive Society which stops at Bromyard on 26th April 1958. (D.K. Jones Collection)

was used. Towards the end of the line's life, trains were often running empty yet there were frequent exceptions to this when special trains were run for hop-pickers. These usually came from Birmingham or the Black Country and for this purpose special stock was used, described as 'third class coaches of the oldest type'.

When rural motor bus services began the line was doomed although it was to be many years before it totally closed. The first section to go was the Leominster to Bromyard stretch which closed completely on 15th September 1952. Afterwards the stretch was used for six years to store some 600 condemned wagons. The last recorded train between Leominster and Bromyard ran on 26th April 1958 hauled by an ex-GWR class 4500 2-6-2T no 4571 – six years after closure! The Bromyard to Worcester section lasted longer with the Bromyard to Bransford Road junction section closing to all traffic on 7th September 1964.

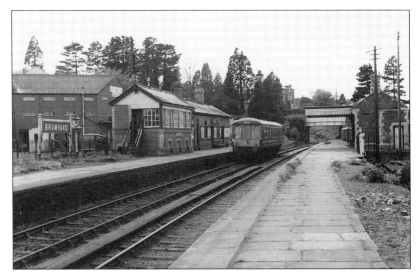

A diesel railcar stops at Bromyard station in the early 1960s. Bromyard, on the Worcester to Leominster branch, closed to all traffic in September 1964. (E.T. Gill/R.K. Blencowe)

When the author toured the line from Worcester towards Leominster many reminders could be found. At Leigh Court the shell of the original station building was still there. It was derelict and covered with ivy, rowan and holly. Situated close to the river Teme, a notice on a gate showed the site to be owned by various Angling Clubs. Visitors were asked to keep out although this warning hardly seemed necessary since the crumbling platform edge was lined with beehives!

In 1957 the Queen and the Duke of Edinburgh visited Worcester and the Royal Train, drawn by two Castle class locomotives, was stabled at Leigh Court. Afterwards the driver of the leading locomotive related that when approaching Leigh Court a horse was reported loose on the line. Detonators had been placed on the track – believed to have been the first time detonators were put in front of a Royal Train.

Before reaching Knightwick there were two short viaducts at

Hayley Dingle and Broad Dingle. Knightwick station building, well to the south of the village, became a private residence known as 'The Heights'. Suckley station became a private residence and at Bromyard the site became an industrial estate. It is from the entrance to this estate that in 1968 the 2 ft gauge Bromyard and Linton Light Railway laid its track. Today the Light Railway is no longer there. The track is still in situ and there are hopes that one day trains might return.

Travelling on westwards, Rowden Mill station is an enthusiast's delight. The station, unstaffed from September 1949, closed to regular passenger services on 15th September 1952. After many years of neglect, a remarkable transformation began in 1984 when the site was acquired by its present owner. Although today a strictly private residence, restoration work by

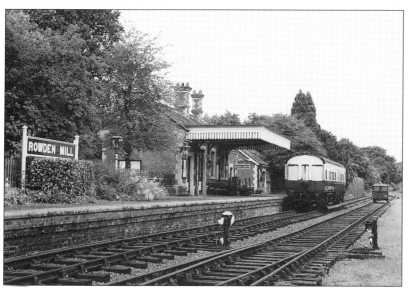

Rowden Mill is a superbly restored station on the former Leominster to Worcester line. After closure in 1952 the station lay derelict until 1984. A great deal of work by the Wilkinson family went into restoration. At the platform stands GWR Inspection Saloon W80976. The station area is strictly private. (Author)

101

Rowden Mill recalls the past with these early station lamps. Restored rolling stock includes LMS Inspection Saloon TDM 395279, Fruit 'C' van no 2815, Metropolitan coach body no 2749 restored as a grounded body and a GWR Toad brake van DW 114751 as well as a fully operational weighbridge. (Author)

the whole family since that time has truly recaptured the past.

At the single platform stands fully restored GWR Inspection Saloon no W80976. Platform seats carry the familiar GWR signs and an advertisement on the fencing reminds visitors that 'Val peppermints 1d aid digestion and safeguard against colds'. Another tells that 'Sunlight Soap' is made by 'Soap Makers to Her Majesty the Queen'. A hut marked 'Rowden Mill East Ground Frame' stands by sections of track. An ex-BR diesel shunter adds realism to the scene. Built originally at Swindon in 1958, it was delivered to Cambridge as no 92. It became BR stock in July 1967 as D2371 and was renumbered 03371 in February 1974. In November 1987 it was withdrawn at Gateshead and a year later it was acquired for use at Rowden Mill. It is currently

A replica of Rowden Mill's East Ground Frame hut has been made and installed. In 1989 the station deservedly won the British Rail Award in the Ian Allan Heritage Awards for the Best Renovated Non-Working Station. (Author)

The locomotive steam funnel by the Ground Frame hut comes from prairie locomotive no 5553, the last to leave Barry scrapyard in 1990. (Author)

painted 'mid-brunswick green' as D2371 and is fully operational and dual braked.

In a nearby siding stands a coach which was originally built in 1936 as kitchen car M30088 for the 'Coronation Scot'. In 1958 it was converted into Inspection Saloon TDM 395279 when it was known as the 'movement manager's saloon'. It was subsequently pensioned off for use as a TOPS training coach at Luton. In 1985 it was moved to Rowden Mill where it was tastefully modified to provide self-catering accommodation for holidays.

It is no wonder that in March 1989 Rowden Mill received the British Rail Award in the Ian Allan Railway Heritage Awards for the Best Renovated Non-Working Station. In 1997 Rowden Mill celebrated its centenary by publishing a booklet on the line as well as providing an open weekend with GWR tank locomotive no 1450 on site for the weekend.

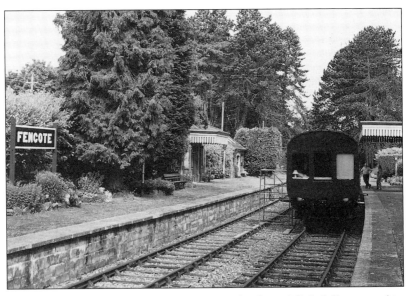

Fencote, between Bromyard and Leominster, has been delightfully restored to its former glory. Posters recall the past – one reads 'Barmouth for mountains, sea and sand'. (Author)

Just under 2½ miles away (or at one time nine minutes by train) can be found Fencote, another splendidly restored station. Like Rowden Mill it is situated in an isolated area and it is hard to believe that either station ever had more than a few passengers at one time. Fencote is another strictly private property but visitors would be welcome whenever prior permission has been received. This is a two platform station with the waiting rooms, parcels office, ticket office and even an old pillar box still intact.

Since the author's first visit to Fencote in 1989 much additional work has been completed. The permanent way by the up platform has been relaid, headshunt and stop blocks completed and foot crossings have been installed. In addition the signal box has been made operational and has a 23 lever frame with six already working and more waiting connection. An LMS Inspection Saloon, PMW 45044, stands at the up platform and

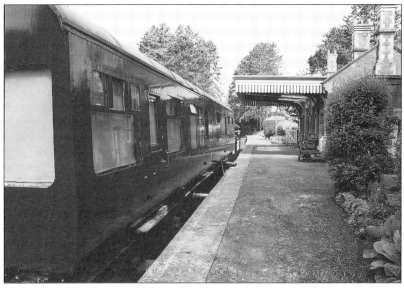

This coach at Fencote was acquired from the GWR Staff Association at Dawlish Warren. Fencote station building and its platforms are strictly private but visitors are welcome with permission. (Author)

105

Fencote station closed to regular passenger traffic in September 1952. Owner Ken Matthews and his wife Barbara have restored not only the station but also the gardens to a high standard. (Author)

has been converted to a camping coach. The coach was acquired from the GWR Staff Association at Dawlish Warren.

In the late 1940s there was a alarming incident when a coal truck was being shunted from Fencote's yard to the 'down' platform. Unfortunately it was not known that the wagon's parking brake was defective and, since the station stood at the highest point on the branch (685 ft above sea level), the wagon continued on its way. Signalmen along the line were alerted and, after gathering speed down a falling gradient of 1 in 30, it passed through Steens Bridge (2½ miles on) at around 60 mph! It was decided to set the line so the wagon would run into the Leominster engine shed siding and stand back and wait. The wagon duly arrived, smashed the stop blocks and demolished itself, scattering the coal down a bank.

Steens Bridge station has given way to a small housing estate

In its time, Leominster was an important junction. Trains for Worcester, also the Kington branches, left from the east side of the station (on the left in the picture). Photograph c1910. (Lens of Sutton)

Leominster station June 2001. The 1455 hrs train to Portsmouth Harbour prepares to stop. With the branch lines long since gone, Leominster is reduced to a two-platform station. (Author)

107

built on the site with semi-detached bungalows built along what was the platform edge. A bridge over the A44 Leominster road has been demolished. Beyond Stoke Prior Halt the track curved sharply northwards to run parallel for over a mile to the Shrewsbury & Hereford line. The trackbed along this latter stretch has become part of today's A49 Leominster bypass.

Passing as it did through delightful and unpopulated countryside, one had the feeling that this was a line that was doomed to failure before it really started.

8
A Link With South Wales

The Hereford, Hay-on-Wye & Brecon Railway
The former Bulmer Railway Centre

GWR locomotive no 2920 Churchward design 4-6-0 'Saint David' built 1907 and withdrawn in 1953, photographed at Hereford station 1951. Locomotive 2920 was the last of the Saint class and sadly not preserved. This was one of the few locomotives painted in BR lined black livery. (D.K. Jones Collection)

The Hereford, Hay-on-Wye & Brecon Railway

The Kinnersley Arms was once known as Station Hotel, at a time when the Hereford, Hay-on-Wye & Brecon Railway

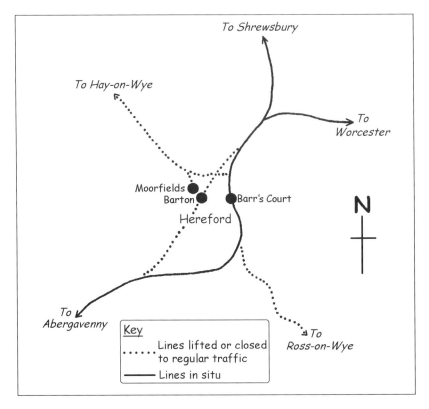

(HH&BR) served the village. Kinnersley station opposite the public house closed in December 1962 yet some locals could still recall racing to the station in the 1920s arriving just in time to catch one of the four daily trains to Hereford. Three of the trains came from Swansea (the early one started at Brecon) with as many as 24 stops for the complete journey which also involved 10 minute waits at Brecon and Three Cocks Junction. The time for such a train to cover the 79¼ miles amounted to just under four hours!

The first section of the HH&BR was agreed by Act of Parliament on 8th August 1859. It opened between Hereford and Moorhampton to goods traffic on 24th October 1862, to

Eardisley to goods and passengers on 30th June 1863 and reached Hay-on-Wye on 11th July 1864. Two months later on 19th September 1864 Three Cocks Junction was reached. The remainder of the line to Brecon had been taken over by different companies before construction had begun. The Three Cocks to Talyllyn section became part of the Mid Wales Railway (later Cambrian Railways) and the Talyllyn to Brecon stretch transferred to the Brecon & Merthyr Railway.

More changes were to follow. The HH&BR had many problems and was taken over by the Midland Railway (MR) in October 1874. Since October 1868 the Midland Railway had been running goods services to Hereford via Worcester and it saw this as a good opportunity to gain access to South Wales via the HH&BR. The MR gained these running powers between Hereford and Worcester having subscribed towards the con-

Western Region 0-6-0 pannier tank locomotive no 3789 plus three coaches awaits departure at Three Cocks Junction probably in the late 1950s. At one time at Three Cocks the Cambrian Railways met the Midland Railway line from Hereford. (Lens of Sutton)

Locomotive 4-6-0 no 6981 'Marbury Hall' arrives at Hereford Barr's Court from Shrewsbury with passenger set on 22nd May 1962. (D.K. Jones Collection)

struction of the line in 1858. Yet the Midland's opportunities were not fully exploited – and neither were its trains welcomed. When the first services reached Hereford, the GWR used an engine and wagon in a blockade to keep them out before matters were finally settled. Thereafter several freight and passenger trains ran daily between Worcester and Hereford giving the Midland Railway a useful through route to Swansea.

In its time Hereford has had three stations. The present station, still known as 'Barr's Court' in railway circles, started life when the Shrewsbury & Hereford Railway (S&HR) opened in 1853. It acquired this name when the S&HR adopted a private dwelling known as Barr's Court for its main station building, still in use today. Earlier stations included Moorfields used by the HH&BR (later Midland Railway) and Barton used by the Newport, Abergavenny & Hereford Railway (later GWR) and not far from Moorfields. When the HH&BR came to Hereford, it

used Moorfields station. When Moorfields closed to passenger traffic on 1st April 1874 trains were diverted to Barton. Moorfields continued as a goods station until 1979. When Barton in its turn closed to passengers the Brecon trains were transferred to Barr's Court.

The HH&BR (MR) remained content with local passenger services over the years and as a freight line it continued as a useful link between Birmingham and South Wales. Freight traffic was hauled mostly by small 0-4-4 tank locomotives whereas many passenger trains were hauled by GWR 0-6-0 74XX tanks. Frequent and unexpected locomotives on the HH&BR were the Lancashire & Yorkshire 0-6-0s which seemed rather remote from their Derby headquarters.

The line like many others survived until the early 1960s but on 31st December 1962 passenger trains ceased. One of the last trains was a special provided by the Stephenson Locomotive

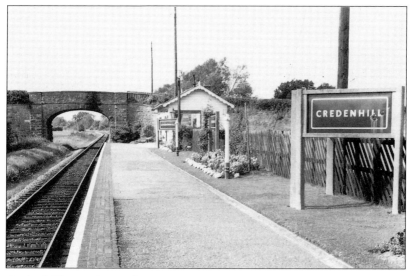

Credenhill's single platform station on the Hereford to Hay-on-Wye line closed to passengers on 31st December 1962. After closure the station site was occupied by a social club. (Lens of Sutton)

113

Society when some 400 enthusiasts bade their farewell and were given black-edged photographic souvenirs. Nearly two years later the line closed to goods traffic between Eardisley and Three Cocks and later the same year the line closed completely.

Much of the original HH&BR trackbed can still be found. At Credenhill the station buildings and platform have completely gone with their place taken by a social club located adjacent to a road bridge. Moorhampton station area is today a Caravan Club site. The platform edges and road bridge are still there and look-ing along the rows of caravans a mound can be seen which once accommodated the signal box. The base and part of a crane sur-vived the years between caravan sites 9 and 10. Kinnersley station building, close to the Kinnersley Arms, is in use as a store and the platform edges can be determined. Hay-on-Wye station has been completely demolished and the site is currently in commercial use.

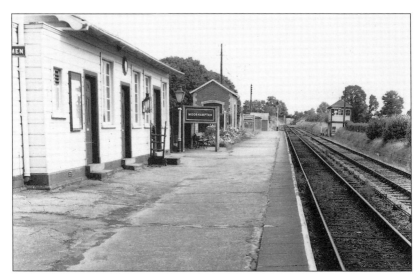

After closure a caravan club took over Moorhampton's station site. During the early 1920s there were four trains each way on weekdays only providing a service between Hereford and Brecon with three trains travelling on to Swansea. (Lens of Sutton)

114

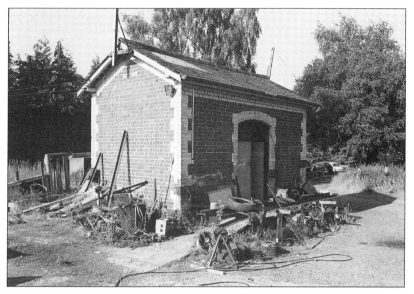

This former goods shed is all that remains of Kinnersley station on the line from Hereford to Hay-on-Wye. The site is today occupied by agricultural suppliers. (Author)

At Eardisley, where the HH&BR met the branch from Kington, the station building was removed piece by piece in the early 1990s to be re-erected at Raven Square, Welshpool, a terminus on the Welshpool & Llanfair Light Railway (see also chapter 4). Eardisley's long main street on the A4111 from Hereford to Kington has two public houses which face each other. One is the New Inn, built in 1902 and resurrected from the original which burnt down. The other is the Tram Inn, commemorating the horse-drawn trams which brought coal from Brecon. On the evening of 12th May 1959 the worst-ever flood swept mud and destruction through the village. With four feet of water in the square, the challenge was to swim from one pub to the other for a free pint!

115

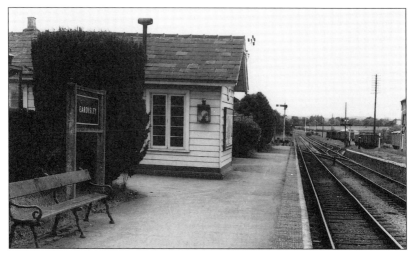

Eardisley closed to passengers in 1962. Thirty years later the station building was dismantled and re-erected piece by piece at Welshpool & Llanfair Light Railway's Raven Square station at Welshpool. (Lens of Sutton)

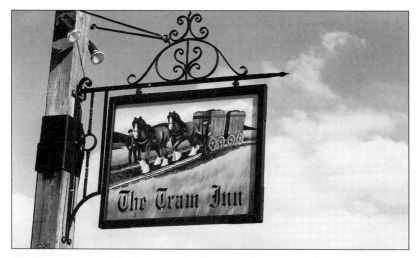

The Tram Inn, a public house at Eardisley on the A4111. The sign recalls the days when coal was carried in from Brecon in horse-drawn wagons. (Author)

116

The former Bulmer Railway Centre

No longer in existence, the Bulmer Railway Centre can justifiably be called another 'lost railway'. For over 25 years it was located in the angle between the ex-Midland Railway line to Brecon and the ex-Great Western line between Red Hill and Barr's Court junctions, just off the A438 road to Brecon at the site of the well-known cider makers, H.P. Bulmer Ltd.

The Railway Centre opened in 1968 to house the famous ex-GWR 4-6-0 King class locomotive no 6000 *King George V.* The locomotive, part of the National Collection, was loaned to H.P. Bulmer Ltd on condition it could be exhibited and steamed at the centre. In October 1971, the locomotive and the Bulmer

When the 'King' reigned at the Hereford Bulmer Centre. Ex-GWR 'King George V' 4-6-0 no 6000, part of the National Collection, photographed at Bulmers in 1989. The bell on the buffer beam was a memento of an earlier USA trip. The locomotive was returned to the Swindon Railway Museum in 1991. (Author)

117

Cider Train toured the main line to establish what problems there would be if steam operations were reintroduced. The operation was so successful that it resulted in the British Railways Board lifting its ban thus allowing steam to return once more to its tracks. The Railway Centre subsequently became a working depot for steam operations in the area, principally on the 'North and West' route between Newport and Shrewsbury.

King George V has a long and interesting history. Completed in July 1927, it was used initially on an exhibition tour over GWR territory. On 20th July it made its maiden journey hauling the 'Cornish Riviera Express'. Its fame soon spread and in August 1927 it travelled to the USA as a British representative at the Centenary Exhibition of the Baltimore & Ohio Railroad

0-4-0ST 'Pectin' no 1579 steamed up in September 1989 with Brian Dodd at the controls. It originally belonged to the British Aluminium Co and it was named 'Pectin' after one of Bulmers' principal products. Following closure of the Railway Centre, the saddle tank locomotive 'Pectin' has been loaned to the South West Main Line Steam Company based at Yeovil Junction. (Author)

Company. It proved a highly popular exhibit and, to commemo-
rate the occasion, the locomotive was presented with an
inscribed brass bell and gold medal.

By 1928 *King George V* was in regular service, which included
prestige operations such as hauling the Royal Train and the
inaugural runs of the 'Bristolian' and the 'Royal Duchy.' After
nearly two million miles, the locomotive was withdrawn in
November 1962 and stored in Swindon Works. In 1964 it was
transferred to the British Railways Board and moved to
Stratford Works prior to eventual entry into the Clapham
Museum. However, it returned to Swindon in 1966 to await
placing in the newly proposed Swindon Railway Museum but
this did not materialise. It was at this point that H.P. Bulmer Ltd
became interested in acquiring the locomotive which culmi-
nated in the company leasing it in 1968. When the lease expired

*All that was left of the Bulmer Railway Centre in June 2001. The halt was
named 'Vernon', erected to the memory of a former chargehand/fitter Vernon
Lloyd Davies. (Author)*

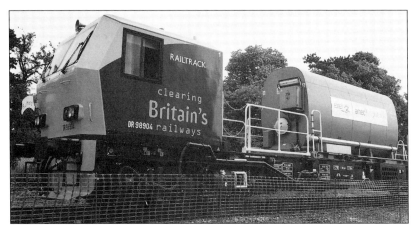

Commercial trials at Bulmers for a new rail freight project to shift kegs by rail instead of road began with an open day on 3rd July 2001. (Photograph courtesy of Bulmers Ltd)

Bulmers' Supply Chain Director, Phil Corfield, signals the start of new rail freight trials throughout the UK. The intention is to despatch deliveries by rail and take pressure of Britain's roads. (Photograph courtesy of Bulmers Ltd)

at the end of 1987, H.P. Bulmer Ltd decided that it should not be renewed. The 6000 Locomotive Association, formed in 1968 to steward the locomotive and operate the Railway Centre on behalf of H.P. Bulmer Ltd, then became the lessees in succession to the company. In 1991 *King George V* returned to the Swindon Railway Museum. Although not in working order, it remains currently on display.

It was inevitable that the area would eventually be required for expansion of the cider works and the centre closed to the public at the end of May 1993. When visiting the site in June 2001 the author found that only a Hunslet locomotive and an old Mk 1 BSK coach remained. The Hunslet, a site shunter belonging to Bulmers, has since been sold to a newly formed group of railway enthusiasts known as 'D 2578 Group'. On 3rd July 2001 the track at Bulmers found new life as a basis for freight trials to transport cider deliveries to all parts of the UK by rail to take pressure off Britain's roads. With Bulmers currently shipping out half a million tonnes of product a year involving some 20,000 lorry movements, it is not surprising that environmentalists have strongly supported such a project.

9
Along The Golden Valley

Pontrilas/Hay-on-Wye

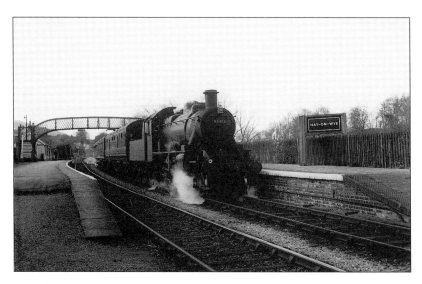

Ivatt locomotive no 46511 class 2MT 2-6-0 with passenger set awaits departure from Hay-on-Wye. The Golden Valley line from Hay-on-Wye to Pontrilas closed in December 1941. (E.T. Gill/R.K. Blencowe)

When the first sod was cut at Peterchurch by Lady Cornewall on 31st August 1876 for a railway line between Pontrilas and Dorstone, there was much excitement. There were flags and decorations everywhere, music was provided by the Herefordshire Militia and, to mark the event, Lady Cornewall was presented with a silver spade and an ornamental wheelbarrow.

One of the first proposals for a line through the Golden Valley had come in a letter published in the *Hereford Times* in August 1875 which stated, 'In times of railway and telegraphic commu-

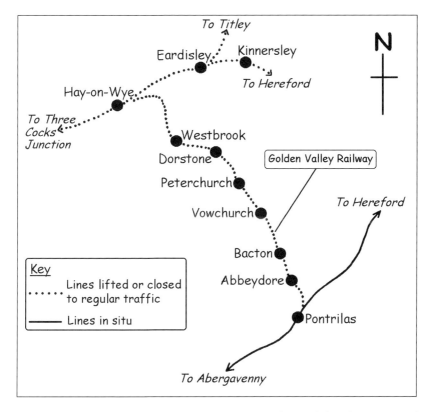

nication is it not very strange that so lovely and fertile a part of Herefordshire should be deprived of cheap and quick transit?' The letter went on to suggest a route from Pontrilas to Eardisley crossing the river Wye near Clock Mills as the 'most level and direct line'.

By the end of September 1875 a meeting was held at the schoolroom in Peterchurch, with a view to promoting such a railway Some considered the idea 'unpromising and most silly' whereas others thought there would be 'useful passenger traffic' in addition to considerable quantities of freight. The latter was expected to include coal, lime and grain as well as large numbers of cattle horses, sheep and pigs.

123

Further meetings followed and the first Golden Valley Railway Act was agreed by Parliament on 13th July 1876. This authorised the building of a line just over 10 miles long from a junction with the GWR to the north of Pontrilas station to the north side of Bridge Cottages in Dorstone. Running powers over the GWR track into Pontrilas station and the use of the station were granted and five years were allowed for completion of the line.

The promoters optimistically thought that such a line might one day become part of a major route from Bristol to Liverpool rivalling the Newport-Shrewsbury main line. To achieve this aim it was considered that a link between Dorstone and Hay would be necessary as well as another southwards towards Monmouth. Parliament agreed a link between Dorstone and Hay by the Golden Valley Railway (Extension to Hay) Act in 1877 as well as additional capital and borrowing being authorised. At Hay the line was to have its own terminus as distinct from the existing Midland Railway station about half a mile away.

The population of Hay celebrated when the first sod for the section was cut by Mrs De Winton of Maesllwch Castle in the upper part of Hay at Caemawr on 31st August 1877. Festivities included a public luncheon in a marquee erected for the occasion with the menu including beef, veal and lamb, roast fowls, ham, ox tongues and roast ducks with many delicacies to follow. Tickets for the lunch which included wine cost 3/6d. Such was the merriment that it mattered little to the local folk that the first sod was cut in a field that did not become part of the actual route later agreed and that a number of years were to pass before their hopes were realised.

Four years later on 1st September 1881, the first train to travel the Golden Valley left Pontrilas but, with the Hay extension plans far from being resolved, only went as far as Dorstone. Pullman type coaches hired from the GWR were used so the guard could collect the tickets during the journey, tickets painted for the occasion in dark green with gold writing. Celebrations continued along the line as residents, young and

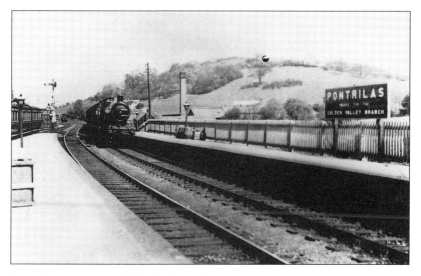

Pontrilas station, c1910. On the left is the bay for trains to Hay-on-Wye along the Golden Valley. A train arrives from Hereford hauled by what appears to be a 4-4-0 GWR County class locomotive. (Lens of Sutton)

old, greeted the train. Lunch and speeches followed at the Boughton Arms at Peterchurch.

During the early years of operation, relations between the Golden Valley Railway and the GWR were not good. There were differences of opinion over the use of Pontrilas station and also through rates and bookings. Between 1876 and 1881 the Golden Valley Company made no less than three approaches to the GWR proposing that it should work the line for initially 60 per cent of the gross profits but each time the idea was turned down.

With a service of only three trains daily in poorly populated areas it was inevitable that the line would not pay. Peterchurch's population in 1881 amounted to 639 only and Dorstone's was less at 445. The small company struggled on using an engine hired from the GWR and its own coaches, one third class and the other a first and second class composite coach. These had been purchased from the Oldbury Carriage Company at just over

A train stops at Peterchurch station, 1887. Today all signs of the station have gone but a small brick building (centre picture) survived the years. (Lens of Sutton)

£1,000 each. In November 1882 the Oldbury company was suing for non-payment and for a time two carriages were hired from the GWR at 15/- a week.

Further problems arose for the Golden Valley Railway over payments due to the GWR for the engine hired as well as rent considered due for the use of Pontrilas station. By October 1883 over £600 was outstanding on the engine so it was withdrawn by the GWR and on 20th October services temporarily ceased. An agreement quickly followed whereby a rental for the use of Pontrilas was agreed and the locomotive came back. In return the GWR retained all Golden Valley receipts at Pontrilas using them to discharge the rent outstanding.

Matters continued to deteriorate and in 1884 further attempts were made to get a working agreement. An approach to the Mid Wales Railway asking if it would work the line for 40 per cent of

126

the gross profits came to nothing so a further approach was made to the GWR. This offered 90 per cent of the gross receipts, falling to 55 per cent when receipts reached a certain level. The GWR agreed to negotiate provided the line was put in good condition at a cost which the GWR initially put at £5,016. The Golden Valley Railway could not raise such a sum so the figure was reduced by the GWR to £3,000. On 2nd July 1885 the company decided to suspend all passenger services although a goods train worked the line four days a week. The excuse for closing the line was that it needed re-sleepering, a task that was in fact carried out with the help of money promised.

Golden Valley board director Richard Dansey Green-Price (later Sir Richard) felt strongly that the GWR offer should be rejected and that an extension from Dorstone to Hay should proceed without delay. Arguments and resignations followed, the resignations including the chairman, E.L. Gavin Robinson. In the end Richard Green-Price got his way. At a meeting of the Golden Valley board held at Peterchurch on 18th July 1885, the new directors agreed that it was 'inexpedient to enter into an agreement with the Great Western or any other company which did not provide for working the line as a whole to Hay and that the directors take means for constructing the Hay extension forthwith'.

The line was reopened on 19th August 1885, but this time using the company's own coaches although it is not clear from records which were used. It is known that in 1886 two four-wheeled composite coaches were bought from the receiver of the Bishop's Castle Railway – a line even less successful. Business improved somewhat for on August Bank Holiday 1886 between 600 and 700 passengers were carried between Pontrilas and Peterchurch and extra carriages had to be hired from the London & North Western Railway (LNWR).

On 27th May 1889 the extension from Dorstone to Hay finally opened, 12 years after the Act had been agreed. Even then a regular service was delayed mainly because late rains had made the permanent way soft and the line needed repacking and regulating. Over the next few years there were further problems.

127

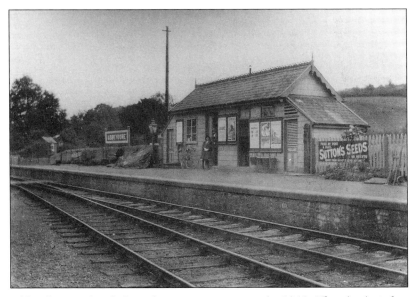

Abbeydore station before closure to passengers in 1941. The site is today occupied by a farm building. (Lens of Sutton)

Finance remained a obstacle to the extent that in 1892 there was a threat that the rolling stock would be withdrawn if the hire charges were not met. To stop the coaches being removed, all the level crossing gates were padlocked but they were smashed open and the coaches taken to the engine shed at Clifford where they were locked up. However the company raised enough cash to provide a new train of two four-wheeled coaches from the LSWR painted in yellow and green, the Golden Valley colours. In addition another tank locomotive, a 2-4-0T, was obtained from the LNWR.

Troubles returned for by August 1897 the line between Dorstone and Hay was considered unsafe to the extent that train services ceased. Eight months later on 20th April 1898, the remainder of the line was closed and the staff were discharged. It seemed that nearly twenty years of local effort and achievement had come to a sad end, but it was not to be the end of the

128

Bacton station saw little passenger traffic during its existence. In earlier times it was known as Bacton Road and it was a conditional stopping place. (Lens of Sutton)

line. By the Great Western Act of 1899, the GWR bought the railway for £9,000 – it had cost over £330,000.

The GWR relaid the track and scrapped the old engine and rolling stock. The line reopened on 1st May 1901 using 0-4-2 class 517 tank locomotives, reintroducing the basic service of three 'mixed' passenger and freight trains daily. Business improved with the benefit of through rates. Over the years to come there were few changes. By the late 1930s a motor bus service commenced between Hereford and Hay providing competition to the trains along part of the route and the number of train passengers began to dwindle.

The end for railway passengers came on 15th December 1941 during the early part of the war. Goods traffic continued and a siding was put in at Elm Park between Pontrilas and Abbeydore leading to a Ministry of Supply depot. After the war the line

closed in stages. On 1st January 1950 the line (by now nation-alised) closed completely between Dorstone and Hay. One last passenger working was on 17th August 1950 when 300 school-children travelled from Dorstone to Porthcawl for an annual outing. The section from Abbeydore to Dorstone closed on 2nd February 1953 and the last section from Abbeydore to Pontrilas went on 3rd June 1957. Removal of the track soon followed except for a short section leading towards the MoS depot which survived until December 1968.

During the life of the line the directors made several applica-tions to Parliament seeking agreement for its proposal of a line southwards to Monmouth. Three versions of a Monmouth Extension Bill were submitted over the years but all failed. With such a line covering a sparsely populated area and through the narrow, steep-sided Monnow valley the idea had little hope. At one stage it was ambitiously proposed that the company should be renamed the Midland, Monmouth & Severn Bridge Junction Railway. History tells us such a line was never built but had it happened then the fortunes of the Golden Valley might have proved quite different.

Today over a dozen trains daily, a service between Hereford and Newport, race past Pontrilas station building which has survived as a private residence since its closure to passengers on 9th June 1958. 'Station House' serves today as a good base to explore the Golden Valley with B&B and cottage accommoda-tion facilities. The nearby siding once held trains bound for Hay-on-Wye, today it is used by trucks carrying products from Pontrilas Sawmills, the largest timber merchants in the country. Beyond it stands a wooden signal box which dates back to the 1890s, still in current use.

Remnants of the railway can still be found along the route. Just to the north of Pontrilas bridge abutments can be seen which once carried Golden Valley trains over the A465 towards Abbeydore and beyond. A few miles further on and a plate lay-ers' hut at Bacton is in use as a store. At Dorstone (beyond Peterchurch) there's a platform edge hidden in the grass but it may be difficult to find. To the east of Hay-on-Wye, bridge abut-

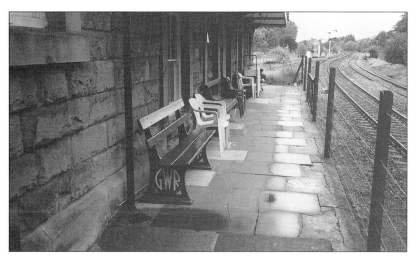

Pontrilas station closed to passengers in June 1958. The station building is today attractively presented as a bed & breakfast stop and there is also a holiday cottage. Plenty of railway memorabilia for the enthusiast! The siding remains in use by a nearby sawmill. (Author)

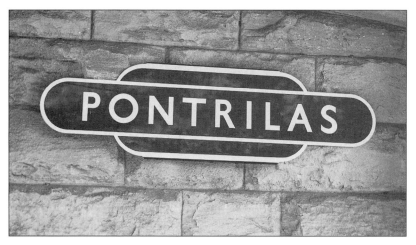

The past is recalled at the former Pontrilas station with this replica station sign on the platform building. (Author)

131

This buttress was formerly part of a bridge which carried Golden Valley trains over the A465 where the track curved away from the main line from Pontrilas towards Abbeydore. (Author)

ments have survived. Hay-on-Wye station, once a busy railway junction, has been totally demolished and the site is currently in commercial use. Throughout the former line some sections of trackbed are easily identifiable but many have been ploughed in to become farmland.

At Peterchurch, some years back, churchwarden Brian Williams recalled one of the last journeys made from the station. It was a trip to Barry Island (with a change at Pontrilas) in a train that was packed with holidaymakers.

The church at Peterchurch has quite a history too. The villagers take quite a pride in their 186 ft spire erected in 1972 and made of fibreglass. The earlier church spire, built in 1320, had to be demolished in 1949. Before it was taken down and during a period that it was covered with scaffolding, it became the object of a bet involving one of the line's engine drivers. The GWR man

132

Peterchurch station in years gone by There was a time when a GWR man was dared to climb the church steeple whilst his train was standing in the station! (Lens of Sutton)

was dared to climb to the top of the steeple and this he did whilst his train was standing at the station. Not only did he win his bet but he left his driver's hat on the top and retrieved it the next day!

133

10
GWR Lines To Gloucester And Monmouth

Hereford/Ross-on-Wye/Gloucester
Ross-on-Wye/Symonds Yat/Monmouth

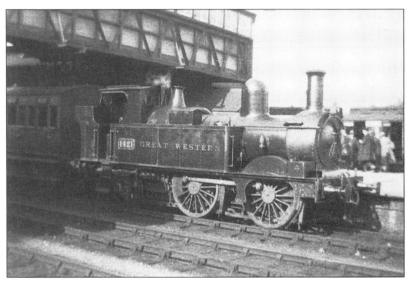

GWR 0-4-2T no 1421 class 517 (J. Armstrong design) built by W. Dean in 1877 at Hereford Barr's Court in 1927. Barr's Court station first opened in 1853 having acquired its name from a private dwelling of the same name adopted for use as the main station building. (D.K. Jones Collection)

Hereford/Ross-on-Wye/Gloucester

Towards the end of March 1947 there had been heavy rains in the area south of Hereford and the river Wye had been running

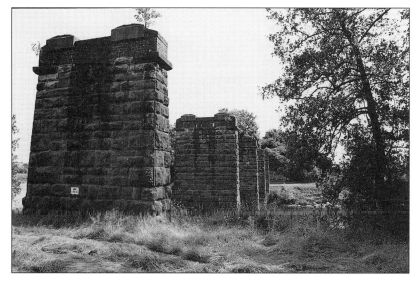

The piers of Strangford Bridge are today still in situ across the river Wye. In 1947 the centre pier plus two adjoining sections of this pier collapsed into the river causing near disastrous consequences. (Author)

high. At about 11 pm on the evening of Friday, 28th March, some 20 minutes after a goods train had crossed Strangford Bridge (between Ballingham and Fawley), the local residents around Fawley heard a loud roar and rushed out to investigate. To their horror they found that the centre pier of the bridge over the river had collapsed bringing down with it the two adjoining sections.

The residents quickly informed the signalman at Fawley who promptly passed a message to Ross station to ensure that all traffic was diverted from the bridge. The stonework of the pier had entirely disappeared into the river and the adjoining troughs, weighing in all some 50 tons, formed a V-shape from the piers on either side into the bed of the river. A replacement bridge was completed within six months. The blame was put down to heavy floods undermining the foundations although many thought it more likely the bridge was weakened during the Second World War when bombs during a Blitz fell within

135

200 yards. Several had fallen in the area and it was thought likely these were intended for the ammunitions factory at nearby Rotherwas.

Broad gauge services between Hereford, Ross-on-Wye and Gloucester began on 2nd June 1855. The route had first been surveyed in 1844 but due to a monetary crisis in 1847 all work had to be abandoned. The prospect was revived in 1850 when a capital of £275,000 was proposed for the 22½ miles involved and a Bill was submitted to Parliament. This was agreed in April 1851 but construction took several years because of the many deep cuttings involved. In addition to this there were four tunnels and four crossings over the Wye. The first 5 miles from Grange Court, a junction with the Gloucester & Forest of Dean Railway, were completed on 11th July 1853, reaching a temporary station at Hopesbrook. It took a further two years for the remainder to be completed.

On the day before the opening, the line was 'severely tested'

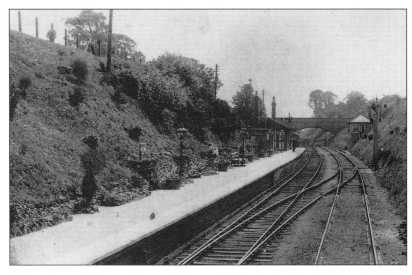

Holme Lacy between Ross-on-Wye and Hereford. The station closed to passengers on 2nd November 1964. The station buildings have gone but the bridge is still there carrying the B4399. (Lens of Sutton)

by what was then considered to be an immense engine (weighing over 50 tons) which travelled the entire route and back. On the day itself, a train was run through from London conveying GWR representatives which included Brunel himself. At Gloucester the party was joined by the local directors and, on reaching Ross, there were great celebrations. The travellers received a 'memorable ovation' after which came a civic welcome with a procession.

In 1862 the local company was absorbed by the GWR which had become concerned over the West Midland Railway takeover of several neighbouring railways. Four years later in 1866 the GWR converted the line to mixed gauge, thus making through goods services to the Midlands possible from Bristol via Gloucester and Hereford.

The line never achieved great importance although sometimes it was used by north-to-west expresses on Sundays when

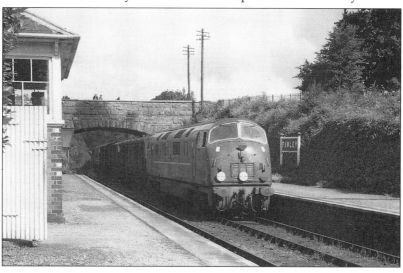

A diesel hauls freight wagons through Fawley station not long before closure of the line in 1964. At the height of steam travel, seven trains daily called on weekdays only travelling between Hereford and Gloucester with most connecting with trains to London Paddington. (Lens of Sutton)

the Severn Tunnel was closed for engineering. Weekday passenger services in the 1920s numbered little more than half a dozen daily, with the journey taking one hour twenty minutes, stopping at each of the eight intermediary stations. Passenger closure between Hereford, Ross and Grange Court came under the Beeching axe on 2nd November 1964 with certain goods services following about a year later.

The line can still be traced today. At Holme Lacy a section of the trackbed has been cleared by members of an adjacent Agricultural College to make way for a bridlepath. Ballingham station building has become an attractive private residence, rebuilt with a second storey in 1973. Piers still stand forlorn across the Wye at various points and old tunnel entrances can be found. Ross-on-Wye station may have been completely demolished but when visited by the author in July 2001 a Railways in Miniature Museum in the town centre served as a good and accurate reminder in model form.

Ross-on-Wye/Symonds Yat/Monmouth

Symonds Yat, the well-known resort 8 miles to the south-west of Ross-on-Wye, is split into two by the river Wye. Although the two halves are only 100 yards apart, it takes a 4½ mile car trip to travel from one half to the other. Many tourists climb Yat Rock which stands 473 ft above sea level at the neck of a 4 mile loop in the river and where magnificent panoramic views can be seen. Nearby are the Seven Sisters Rocks and the fancifully named King Arthur's Cave where the remains of Stone Age man and of mammoths and woolly rhinoceroses have been found.

Looking down from Yat Rock it was once possible to determine the course of the Ross & Monmouth Railway where trains wound their way along picturesque riverbanks and through cuttings to emerge from a short tunnel into Symonds Yat station. Long before motor cars clogged the roads in the area, some six trains each way daily (Sundays excepted) used the line.

The Ross & Monmouth Railway was authorised by Parliament

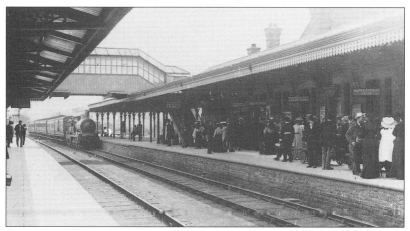

The days when passengers were plentiful. A GWR 0-6-0 Dean goods locomotive hauls a passenger train into Ross-on-Wye station, c1910. (Lens of Sutton)

Ross-on-Wye station may have gone but it lives on in model form at a Railways in Miniature Museum in the town's Copse Cross Street. Trains from 1880 to 1947 are exhibited as well as numerous other exhibits. (Author)

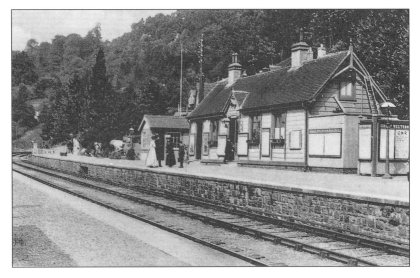

Symonds Yat station, c1910. Beyond to the left is the entrance to Symonds Yat tunnel where railway engineers had great difficulty in cutting through hard rock strata before the line could be opened. (Lens of Sutton)

on 5th July 1865 and such was the arduous work entailed that it took eight years to build. Trial borings at Symonds Yat tunnel indicated that there would be considerable difficulty cutting through the hard strata. As a result the directors deferred commencing operations until they were sure that finance was adequate. The original powers for the line had indicated broad gauge but these were allowed to lapse after which the Bill was resuscitated and promoted as narrow gauge.

On leaving Ross-on-Wye the first intermediate station towards Monmouth was Kerne Bridge, popular with visitors for Goodrich Castle. Next came Lydbrook Junction where there was a connection with the Severn & Wye Joint Railway by which the Forest of Dean Central Railway could be reached. This latter railway opened in 1850 for mineral traffic and today part of it provides a base for the popular Dean Forest Railway Preservation Society. Beyond Symonds Yat station came

140

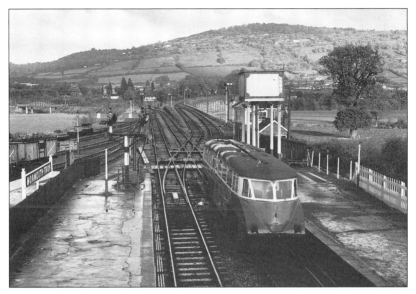

A GWR diesel railcar W4W arrives at Monmouth Troy station from Severn Tunnel Junction (via Chepstow) on 5th November 1955. This is one of the early series of GWR railcars, now preserved. Trains left Ross-on-Wye and Hereford to the left and the Wye Valley across to the right. (Picture courtesy of Hugh Ballantyne)

Monmouth Mayhill which formed a temporary terminus when reached from Ross on 4th August 1873. The complete stretch to Monmouth Troy was completed on 1st May 1874.

Although worked by the GWR, the line retained its nominal independence until 'grouping' in 1922. The line was lightly used throughout its life but there was heavy day-trip traffic and during the Second World War there was substantial freight and passenger traffic. Prior to the withdrawal of passenger services on 5th January 1959, a TUCC enquiry was held. BR claimed that the line was heavily losing money yet it was pointed out at the enquiry that BR had previously renewed the entire track in order to inflate the costs! It was also revealed that BR had estimated that £50,000 needed to be spent on each of the bridges at

141

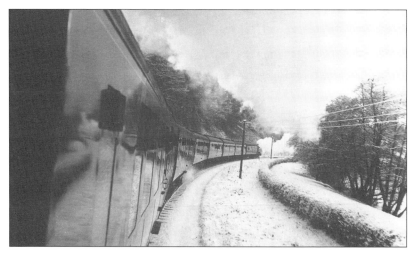

Locomotive no 6412 heads the last train to Ross-on-Wye from Chepstow in the Wye Valley on a snowy 4th January 1959. (D.K. Jones Collection)

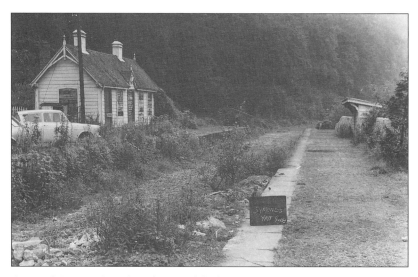

Symonds Yat station after closure of the line in January 1959. The station site is now the forecourt to a hotel overlooking the river Wye. (Lens of Sutton)

Kerne Bridge and Tintern. The TUCC considered this to be too great a sum when no effort was being made to stimulate local or tourist traffic and in addition BR had refused to economise by considering the use of diesel rail-buses. Despite such disclosures, complete closure between Monmouth and Lydbrook went ahead. The Lydbrook to Ross section remained open for goods traffic until 1964.

With Ross-on-Wye, Symonds Yat and the Wye Valley such popular tourist areas, what a pity that the authorities closed the railways in the area. Were they there today they would surely have proved highly popular for locals and the tourist trade alike and also give relief to our overcrowded roads which are quite inadequate for the present volumes of traffic.

11
The 'Daffodil Line' To Gloucester

Ledbury/Gloucester

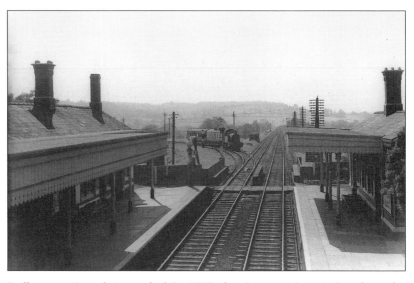

Ledbury station photographed in 1959 showing a train entering from the single-track Gloucester branch. The line opened in 1885 to last only 74 years, closing in July 1959. (E.T. Gill/R.K. Blencowe)

Although most of the track lies in the neighbouring county of Gloucester, the branch from Ledbury, on the existing Hereford to Worcester line, southwards to Gloucester is worthy of mention. The principal centres of population in the area were at Newent and Dymock. Although essentially agricultural in nature, some coal mining existed in the Newent area towards the end of the 18th century.

144

First transport to reach the area was the Hereford & Gloucester Canal. Authorised in 1791, it was planned it should run from the river Severn at Over towards Ledbury where it would turn westwards towards Hereford. The canal was completed in stages through Newent and Dymock and reached Ledbury in March 1798. Its principal feature was Oxenhall tunnel, 2,192 yards long. The section towards Hereford was delayed because of financial problems and opened in May 1845.

When 'Railway Mania' swept the country, the canal directors saw possibilities in the course of the canal being put in use as a railway. Negotiations went ahead but it was to be many years before planning was adopted. The 19 mile stretch, to become known as the 'Daffodil Line', began as two separate concerns. The first, the Ross and Ledbury Railway, was planned to run from Ledbury to Ross via Dymock. The other was the Newent

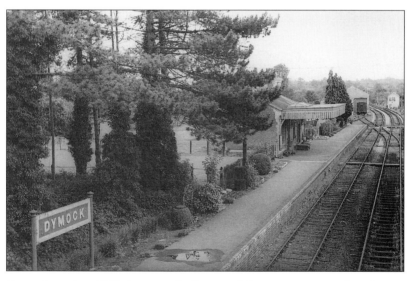

Dymock station, 1960, between Ledbury and Newent, one year after closure to passenger traffic. The line was built to give the GWR an advantage over the Midland Railway with a shorter route between Gloucester and Birmingham. (E.T. Gill/R.K. Blencowe)

Railway which would leave the Ledbury to Ross line at Dymock to reach the Great Western Railway at Over junction, to the west of Gloucester. Both companies gained Parliamentary approval in 1873. Due to shortage of finance nothing happened for about three years at which point the GWR agreed to provide the capital required. The Ross and Ledbury Railway abandoned its plans to reach Ross and linked with the Newent Railway to provide a through Ledbury/Gloucester route.

The through line opened on 27th July 1885. It had been expected that the Oxenhall tunnel might be adapted for railway use but the idea was abandoned and an alternative route avoiding high ground was authorised. There were intermediate stations at Dymock, Newent and Barber's Bridge, all of them in Gloucestershire. Barber's Bridge has been said to derive its name from 'Barbarous Bridge', the site of an encounter in the Civil War. Between Ledbury and Dymock the track was double

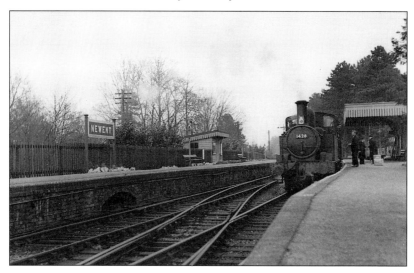

A passenger train headed by ex-GWR locomotive no 1428 0-4-2T class 1400 at Newent awaits departure, 1959. Cast iron crests existed on the awning supports with the initials of the original Newent Railway which received Parliamentary approval in 1873. (E.T. Gill/R.K. Blencowe)

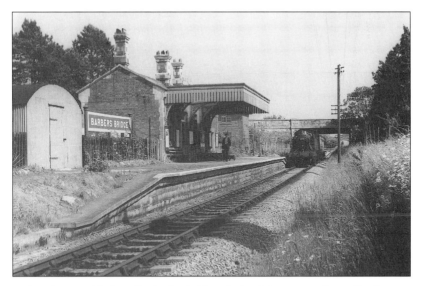

It has been said that Barber's Bridge derived its name from 'Barbarous Bridge', the site of an encounter in the Civil War. The single-platform station was photographed in 1959. (E.T. Gill/R.K. Blencowe)

but the remainder stayed single throughout its life even though embankments and bridges had been built to provide for possible future double track. The line's immediate advantage was to provide the GWR with a shorter route between Gloucester and Birmingham in direct competition with the Midland Railway. The benefit did not last, however, for in 1907 the GWR opened a North Warwickshire line providing an even shorter route to Birmingham via Stratford.

In the early 1920s there were five trains each way on weekdays only. Locomotives, an 'Earl' or a 'Duke' 4-4-0, were used fitted with a very small tenders to allow them to use a turntable at Ledbury. In 1928 a halt at Ledbury Town was opened to provide a more convenient stopping place for passengers. Additional halts followed in the late 1930s at Greenway, Four Oaks and Malswick. In 1957 the double line connection with the main line at Ledbury was taken out, giving a connection on the down line only.

The line closed to passenger traffic on 13th July 1959. The section from Ledbury to Dymock closed completely but the remainder of the track continued to serve goods traffic from the Gloucester end for a number of years. Finally on Saturday, 30th May 1964, BR locomotive standard class 2 no 78001 travelled the line for the last time, collecting empty trucks.

Yet the line was to close with dignity. During its last week, a final passenger train stopped overnight in the area of Lassington Woods between Over junction and Barber's Bridge. The train comprised a locomotive and three carriages from the Royal Train, 'parked' in a secluded spot so that Prince Philip, the Duke of Edinburgh, could have a peaceful night's sleep. Next morning the train left for Birmingham and the moment of glory had gone.

In the early 1990s there were hopes that a section of the former 'Daffodil Line' might reopen. The Leadon Valley Electric Railway Association was formed and there were plans to

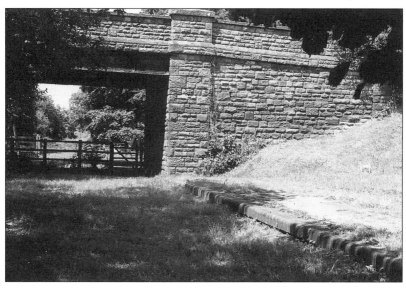

Near old folks' homes and just off Old Station Road at Newent can be found the remains of a platform edge and an over-bridge. Newent closed to passenger traffic in July 1959. (Author)

rebuild standard gauge track from Ledbury to Newent to eventually reach Gloucester. An ex-Brussels 600V DC tramcar was purchased from the West Yorkshire Tramway Museum and the initial plan was to link Ledbury station with the town centre. Unhappily for enthusiasts the scheme did not develop.

Ledbury station is at the western end of the Paddington to Hereford 'Cotswold Line'. Earlier last century Ledbury boasted an impressive array of buildings and it enjoyed junction status. Sadly all this went with the 'rationalisation' of the 1960s, reducing Ledbury to a neglected, unstaffed halt. But all this changed in 1988 when a new station building was erected and a pioneering ticketing and information service was established. At the helm of this project was Gareth Davies who not only sold tickets but provided all the necessary travel information and served tea or coffee to those with a longer wait for a train. In addition there was a waiting area, with games for children and a library offering around 500 books. Today John Geldrick has taken over as Ledbury's new station-master, offering the same friendly service.

At the end of the platform stands a signal box in immaculate condition and sporting a traditional GWR 'Ledbury Signal Box' sign. This controls all manner of passing traffic including Thames Turbos, Central Sprinters and Great Western High Speed Trains travelling between Hereford and London Paddington.

For the rail historian there is a further bonus to be found at Ledbury station. Only a short distance from the booking office and across the car park there is an upright cream-painted post. This is said to have been originally a section of GWR Barlow broad gauge track probably from the Gloucester/Hereford line. At the bottom of the station drive two more such upright posts can be found tied together.

On the existing line between Ledbury and Great Malvern there are two tunnels. Ledbury tunnel is 1,316 yards long and Colwall tunnel is 1,586 yards. The original Colwall tunnel taking trains under the Malvern Hills had to be closed in the 1920s when it was in danger of collapse and a new bore was com-

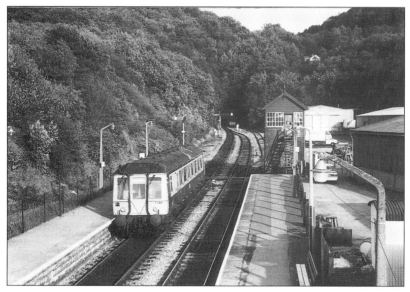

Ledbury station, September 1989 where the line singles to enter the 1,316 yard Ledbury tunnel. A DMU 'Bubble-Car' Sprinter awaits return to Worcester. (Author)

pleted in August 1926. The original tunnel served a useful purpose, however, during the Second World War when it was used to store torpedoes. At Malvern Wells there were numerous huts to accommodate naval personnel guarding this ammunition. Following track realignment for the new tunnel the old track was removed and part of the trackbed area is now used by an industrial estate. Colwall tunnel still serves a useful purpose. It is home to a rare colony of bats.

Conclusion

The decline of many of branches began in the 1920s. Buses were able to offer a more flexible service than the trains and road haulage was on the increase. In addition the private motor car was beginning to make its presence felt. After nationalisation in 1948, the railways, still recovering from the demands of war service, were slow to meet any competition and were losing ground. Reduced revenue was leading to increased economies and then closures, with the entire pattern of inland transport gradually changing.

The branch from Cleobury Mortimer to Ditton Priors was an early casualty. Although built principally for freight, passenger traffic fell disappointingly in its later years and by the 1920s trains were stopping only 'if required'. Perhaps the line's busiest day in the 1930s was on Saturday, 24th September 1938, the day it closed, when two extra coaches had to be added!

There were two further closures during the Second World War. The first came on 1st July 1940 when the short branch from Titley to Eardisley closed completely due to economies. In such rural surroundings it was clear such a line could hardly have survived anyway. The other branch was the Golden Valley Railway from Pontrilas to Hay-on-Wye. The line, opened throughout in 1889, had experienced a chequered career with many financial difficulties. When a motor bus service competed effectively along part of the route, the number of passengers dwindled. The end came on 15th December 1941 with only goods services surviving. Although today, over 60 years later, there are few remains to be found yet the Golden Valley Railway is still remembered by many as a line that had character.

The early 1950s saw the gradual closure of the remaining Kington branches plus the line from Leominster to Bromyard. Towards the end of the decade the branch from Ross-on-Wye to Monmouth succumbed as well as the 'Daffodil Line' from

151

Ledbury to Gloucester. The private motor car and the motor bus were taking over for many as family transport and once popular railway routes were diminishing at a faster rate.

In 1960 the line from Cheltenham to Honeybourne closed. During 1961/1962 five more lines disappeared from the railway map. Busy towns such as Hay-on-Wye, Tenbury Wells or Tewkesbury no longer had passenger railway services. In March 1963 proposals were made in a report which became popularly known as the 'Beeching Plan'. Basically the idea was to keep lines considered suitable to rail traffic and give up the remainder. It was claimed that one third of the rail system in Britain carried only 1% of the total traffic!

Further drastic cuts inevitably followed as many more lines disappeared. Where once existed a network of bustling lines, only a skeleton of services survived. However, the railway's past has not been forgotten. To the north the Severn Valley Railway lives on as a preserved line with the largest collection of locomotives and rolling stock in the UK. Thousands visit this popular line each year which, during 2000, celebrated its 30th anniversary. On a section of a line that once crossed the county's borders, the Gloucestershire Warwickshire Railway at Toddington regularly provides impressive steam services. Much still needs to be done for these preserved lines and such enthusiasm deserves all possible support.

Is it possible that some railways may one day make a comeback and once-axed lines may thrive again? Such plans are certainly worthwhile when considering today's traffic congestion on overloaded and inadequate roads plus the continuing damage to the environment. Tracks on the restored Gloucestershire Warwickshire Railway have already reached Cheltenham Racecourse and hopes remain than one day its trains will reach Broadway and then on to Honeybourne – or even Stratford-upon-Avon?

There has been talk in years past that a section of the Wye Valley might reopen. This could surely do much to not only boost the tourist trade but relieve crowded roads in a popular area but at the present time such an idea can only be considered

a pipe-dream. Such hopes are however strengthened by talk of a 5 mile light rail link (or at least a cycleway) between Hereford and Holme Lacy. This could come about since Holme Lacy College is to become a European Centre for sustainable land-use and, as part of its emerging transport policy, may press the Strategic Rail Authority for a requirement of any new Wales and Borders franchisee for such a proposition. Herefordshire Council is already receptive to putting in a halt or equivalent at Rotherwas Industrial Estate, part way along the Hereford/ Holme Lacey possible route.

From Ross the possibility of reviving the link towards Gloucester has also been discussed. There would be no lack of passengers but over the years trackbeds have been finding other uses. These ideas would meet almost insurmountable problems, particularly finance.

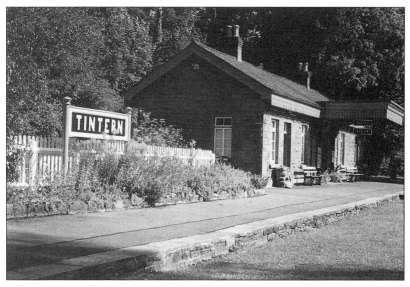

Tintern station, August 2001, is today a tourist attraction known as 'The Old Station, Tintern' under the auspices of Gwent County Council. There is hope that at some future date steam trains may run again between Chepstow and Tintern but probably to a halt nearer the Abbey. (Author)

153

There are also hopes that trains might one day return to the section between Tintern Abbey and Chepstow. A public meeting has showed enthusiasm, some track is already in situ and there are encouraging signs from local county councils and the tourist board. The GWR Preservation Group has said it would offer help with locomotives and rolling stock.

Finally, a thought from the past. When the Birmingham & Gloucester Railway was built there were serious gradient problems over the Lickey Incline between Bromsgrove and Barnt Green. With a gradient of 1 in 37½ involved, the lighter trains needed assistance with additional locomotives (bankers) waiting to assist. But in 1840 a locomotive's pressure became too great and a 28 year old driver, Thomas Scaife, was killed when his boiler exploded. Another fatality was Joseph Rutherford who was with him at the time.

Tombstones for the two men, erected at the expense of their workmates, can be found in Bromsgrove churchyard. Part of a poem written by an unknown friend and inscribed on Thomas Scaife's tombstone reads:

> My engine now is cold and still,
> No water does my boiler fill,
> My coke affords its flames no more,
> My days of usefulness are o'er.
>
> My wheels deny their noted speed,
> No more my guiding hands they heed,
> My whistle too has lost its tone,
> Its shrill and thrilling sounds are gone.

Opening and Final Closure Dates of Lines to Regular Passenger Traffic

Line	Opened	Final Closure
Ashchurch/Tewkesbury	1840	1864
Hereford/Ross-on-Wye/Gloucester	1855	1964
Leominster/Kington	1857	1955
Honeybourne/Stratford-upon-Avon	1859	1969
Woofferton/Tenbury Wells	1861	1961
Shrewsbury/Bewdley	1862	1963*¹
Bewdley/Hartlebury	1862	1970
Great Malvern/Tewkesbury	1864	1961
Tenbury Wells/Bewdley	1864	1962
Hereford/Hay-on-Wye/Brecon	1864	1962
Ashchurch/Evesham	1864	1963
Evesham/Redditch	1868	1962
Ross-on-Wye/Symonds Yat/Monmouth	1873	1959
Titley/Eardisley	1874	1940*²
Titley/Presteigne	1875	1951
Kington/New Radnor	1875	1951
Bransford Road/Bromyard	1877	1964
Bewdley/Kidderminster	1878	1970*¹
Pontrilas/Dorstone	1881	1941*³
Ledbury/Gloucester	1885	1959
Dorstone/Hay-on-Wye	1889	1941*³
Bromyard/Leominster	1897	1952

Cheltenham/Broadway/Honeybourne 1906 1960*4
Cleobury Mortimer/Ditton Priors 1908 1938

*1 Steam trains recommenced at Bridgnorth on May 23rd 1970 when the Severn Valley Railway Society started limited services. Bridgnorth/Kidderminster services started on 30th July 1984.

*2 Temporary closure – January 1st 1917 to 11th December 1922.

*3 The Golden Valley line closed temporarily at times between 1885/1901 because of financial difficulties. It was acquired by the GWR in 1899.

*4 Steam trains returned to Toddington on 22nd April 1984 when the Gloucestershire Warwickshire Railway commenced services over a ¼ mile section.

Bibliography

In compiling *Lost Railways of Herefordshire and Worcestershire*, I have referred to numerous sources, many now out of print, which include the following and which can be recommended for further reading:

Christiansen, Rex *A Regional History of the Railways of Great Britain Vol 13 Thames & Severn* (David & Charles)

Christiansen, Rex *Forgotten Railways Vol II Severn Valley and Welsh Border* (David & Charles)

Cook, R.A. and Clinker, C.R. *Early Railways between Abergavenny and Hereford* (Railway and Canal Historical Society)

Maggs, Colin and Nicholson, Peter *The Honeybourne Line* (Line One Publishing Ltd)

Marshall, John *The Severn Valley Railway* (David St John Thomas)

Mowat, Charles Loch *The Golden Valley Railway* (University of Wales Press)

Postle, David *From Ledbury to Gloucester by Rail* (Amber Graphics, Ledbury)

Rolt, L.T.C. *Red For Danger* (Pan Books Ltd)

Russell, Ronald *Lost Canals and Waterways of Britain* (David & Charles)

Smith, W. and Beddoes, K. *The Cleobury Mortimer and Ditton Priors Light Railway* (Oxford Publishing Co)

Sources also included *Sleepers Awake* (part one 1981 to 1985) published by the Gloucestershire Warwickshire Railway and the booklet *Bulmer Railway Centre . . . a brief guide*.

Index